# STRANGE
## — AND —
# UNSUNG
# ALL-STARS
## OF THE  DC MULTIVERSE
# A VISUAL ENCYCLOPEDIA
## STEPHANIE WILLIAMS

RUNNING PRESS
PHILADELPHIA

Hachette Book Group supports the right to free expression and the value of copyright. The purpose of copyright is to encourage writers and artists to produce the creative works that enrich our culture.

The scanning, uploading, and distribution of this book without permission is a theft of the author's intellectual property. If you would like permission to use material from the book (other than for review purposes), please contact permissions@hbgusa.com. Thank you for your support of the author's rights.

Running Press
Hachette Book Group
1290 Avenue of the Americas, New York, NY 10104
www.runningpress.com
@Running_Press

Printed in China

First Edition: November 2023

Published by Running Press, an imprint of Perseus Books, LLC, a subsidiary of Hachette Book Group, Inc. The Running Press name and logo are trademarks of the Hachette Book Group.

The Hachette Speakers Bureau provides a wide range of authors for speaking events. To find out more, go to www.hachettespeakersbureau.com or email HachetteSpeakers@hbgusa.com.

Running Press books may be purchased in bulk for business, educational, or promotional use. For more information, please contact your local bookseller or the Hachette Book Group Special Markets Department at Special.Markets@hbgusa.com.

The publisher is not responsible for websites (or their content) that are not owned by the publisher.

Print book cover and interior design by Alex Camlin.

Library of Congress Control Number: 2022059383

ISBNs: 978-0-7624-8344-0 (hardcover), 978-0-7624-8345-7 (ebook)

APS

10  9  8  7  6  5  4  3  2  1

# CONTENTS

FOREWORD BY JAMES GUNN . . . VII

PEACEMAKER . . . 1

PARTY TRICKS . . . 7

MAL DUNCAN . . . 38

BAD DAY AT WORK . . . 43

BROTHER POWER . . . 53

CHEMISTRY 101 . . . 57

RED TORNADO . . . 68

ROUND, OFTEN LARGE, AND RARELY IN CHARGE . . . 71

DANNY THE STREET . . . 81

9 TO 5 TO CRIME . . . 85

MIA "MAPS" MIZOGUCHI . . . 92

HAIR VIBES . . . 95

KING SHARK . . . 102

LEANING INTO THE ANIMAL KINGDOM . . . 107

THE CREATURE COMMANDOS . . . 129

GROUP PROJECTS . . . 139

JET . . . 186

DEJA VIEW . . . 191

DR. CLAIRE FOSTER . . . 201

TECHNORABBLE . . . 205

CHESHIRE . . . 216

OUT OF THIS WORLD . . . 219

QUISLET . . . 226

WRITER AND ILLUSTRATOR CREDITS . . . 228

ACKNOWLEDGMENTS . . . 231

ABOUT THE AUTHOR . . . 232

# FOREWORD

*"WE'RE NOT HERE FOR THE BEAUTIFUL PEOPLE, TED. WE'RE HERE FOR THE ODDBALL, THE REBEL, THE OUTCAST, THE GEEK!"*

**T**HAT'S A LINE FROM THE FIRST SUPERHERO MOVIE I EVER wrote, *The Specials*, way back in 1998, and made for under a million dollars. The quote has been playing in my mind repeatedly after reading *Strange and Unsung All-Stars of the DC Multiverse*, a celebration of DC's oddest oddballs.

I love DC comics for the wondrous art and beautiful stories and incredible characters. The classics of DC are certainly the greatest superhero myths in comic book literature, from *Batman: The Long Halloween* to *Watchmen* to *All-Star Superman*. But I also love the goofy underbelly of DC, the outrageous characters sometimes created in a tongue-in-cheek manner (I don't think anyone ever thought Condiment Man was a threatening villain), and other times without irony (I'm not sure Hornblower's costume was originally seen as the crime against fashion it is).

This is a book that honors that goofy underbelly of the DC Multiverse, giving light to the surreal gunk that gets stuck to the sides of your brain whether you like it or not after sliding through eighty years of comic book superheroes. This is a book about—and, probably, with all due respect, for—the oddballs, the rebels, the outcasts, and the geeks.

Welcome to the club. Long may the weirdness reign.

*—James Gunn*
*April 2023*

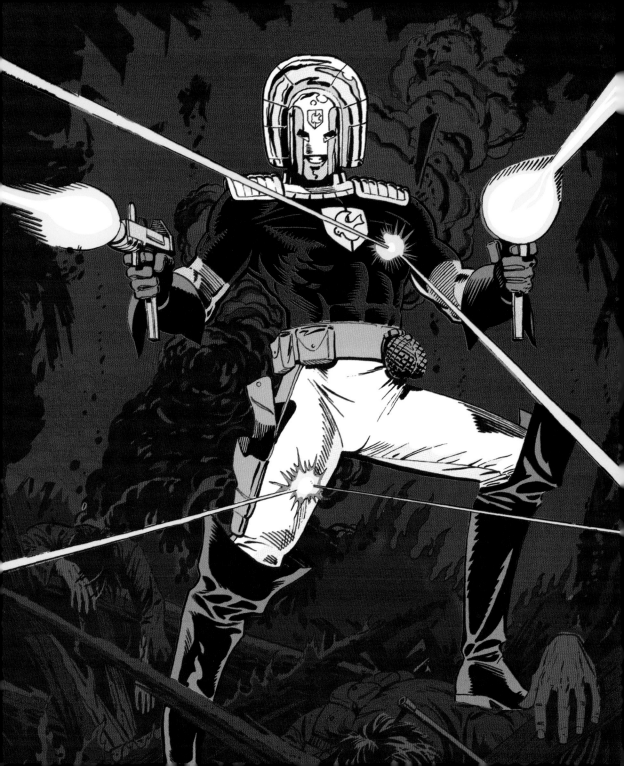

# PEACEMAKER

FIRST APPEARANCE: *FIGHTIN' FIVE* #40 (NOVEMBER 1966)

PEACEMAKER IS THE REASON WE'RE ALL GATHERED HERE TODAY. A CHARACTER WHO STARTED POPULAR ENOUGH TO BE GIVEN HIS OWN SERIES THEN FELL BACK INTO OBSCURITY, ONLY TO COME OUT ON TOP IN THE END. PEACEMAKER IS AN EXCELLENT EXAMPLE THAT ALL THINGS ARE POSSIBLE, EVEN FOR THE MOST UNLIKELY COMIC CHARACTER. SOMETIMES IT JUST TAKES A WHILE FOR THEM TO HAVE THEIR MOMENT.

**P**EACEMAKER WASN'T EVEN A DC CHARACTER TO START. He made his debut as a Charlton Comics character in backup stories of the *Fightin' Five* comic book series. In his first appearance, Christopher Smith is described as a man who detests violence and loves peace. His desire to prevent the waste of human life in senseless conflicts between nations makes him willing to fight for it at any cost: he becomes Peacemaker after he concludes violence is the only solution to stopping violence—after all, a negative multiplied by a negative does have a positive outcome. It's an interesting philosophy to say the least, and one that made Peacemaker's exploits in his first appearance action packed.

Peacemaker made the most of his two appearances in the *Fightin' Five* series; it even worked in the character's favor when the series was canceled right after. In a twist of fate, Peacemaker went on to get his own short-lived series, with the Fightin' Five now appearing in the backup stories. The *Peacemaker* solo series expanded on the adventures of this James Bond–like character who traded in his smoker's jacket for a helmet resembling a bedpan, riding boots, and a jetpack. There was a suaveness to Christopher Smith that overpowered the absurdity of his suit. Although this series was also canceled, the character had managed to become one of Charlton Comics' most popular Action Heroes.

DC later acquired some of those Charlton Action Heroes, including Peacemaker, who were introduced into the DC Multiverse by way of the *Crisis on Infinite*

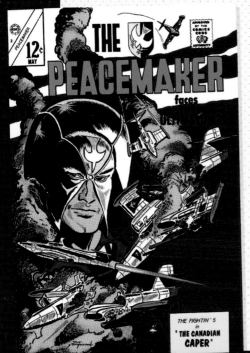

*Earths* maxiseries, with Peacemaker debuting in #6. During the events of this maxiseries, he and the other Charlton characters were revealed to have existed on Earth-4—one of five surviving Earths to converge into a single composite Earth—and they were given new origins.

In this new post-*Crisis* reality, Peacemaker was introduced as Christopher Schmidt, the son of Austrian munitions manufacturer Wolfgang Schmidt and US children's book author Elizabeth Lewis. Like many other DC characters, Christopher's childhood was marked with trauma—he discovered his father was an elite Nazi officer of the SS corps who chose to commit suicide before he could be arrested. After witnessing his father's death, Christopher relocated with his mother to the United States, and she changed their last name to

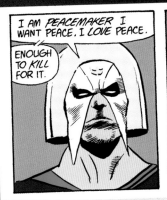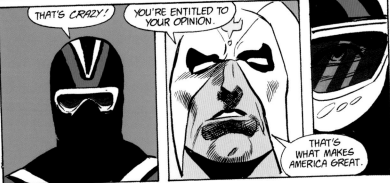

Smith. However, Christopher's father would become a mainstay in his thoughts, eventually transforming into a constant voice in his head.

Christopher began experiencing visions of Wolfgang speaking directly to him, urging him to excel in his schoolwork so he could be worthy of Wolfgang's legacy. Despite his father's wicked history, Christopher listened. In that instance it worked out in his favor, though years later the same could not be said. While Christopher was serving in the US military, he massacred a village of innocent people as the result of a combination of Wolfgang's prompting and an error made by military intelligence. He was court-martialed and sentenced to twenty years at Leavenworth federal penitentiary, but he did not remain incarcerated. Christopher was offered a pardon nearly two years into his sentence. His release was contingent on joining Project: Peacemaker, a top-secret, high-tech, independent anti-terrorist group. The program lasted only eight months, until the incoming Ford administration shut it down. Members like Christopher got lost in the bureaucratic shuffle. Not taking his good fortune for granted, Christopher wasted no time disappearing. He returned to his native Austria, taking over his father's businesses and also heading up the Pax Institute—a charity dedicated to providing aid to war victims—in Geneva.

Reflections of the Charlton incarnation of Christopher began to shine through once he started his own Project: Peacemaker program. He had a two-prong

approach to achieving peace. One involved his civilian identity with the charity, and the second involved his alter ego, Peacemaker. This version of Peacemaker was a one-man army with advanced weapons. The helmet was now upgraded with heat- and pressure-proof plastic containing cybernetic circuitry that operated an all-wave radio receiver and transmitter, an ultrasonic stun beam, and a laser beam that fired from a spot on the forehead. His gloves held a vial that became a firebomb when crushed, his boots contained an explosive pentolite compound, and his holster carried ammunition, a miniature tool kit, pellets of a concentrated nerve gas, and shark sedative (because you never know when you'll need to take out a great white). Peacemaker also wore a mini–jet pack that worked in both air and water.

He also received a permanent resident in his mind—Wolfgang's spirit began harassing him even more. Christopher's mental health declined as he started to believe the souls of those he could not save some-how lived in his helmet. He became increasingly violent as a result, and his desire for peace only drove him to more extreme and deranged actions. While making a name for himself as Peacemaker, he caught the attention of a secret government group called the Agency. Once they discovered his secret identity, they coerced him into joining. The Agency chair Valentina Vostok saw to getting Christopher therapy to temper his psychological problems.

Peacemaker continued to work for the Agency after it was transformed into a new organization named

THAT'S NOT A HALF BAD IDEA, MAZARIN. PERHAPS YOU SHOULD START PRAYING--

--SINCE I'M GOING TO *SEND* YOU STRAIGHT TO *HELL!*

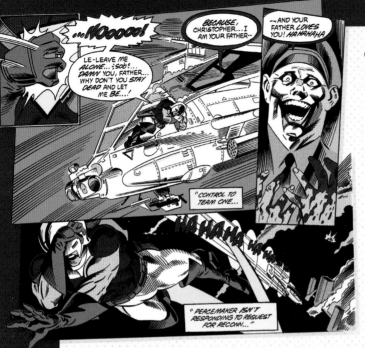

Checkmate, until he was recruited by Amanda Waller to join the Shadow Fighters—a group of heroes brought together to defeat Eclipso. Peacemaker was among the heroes killed in the mission, but thanks to the ever-shifting nature of reality of the DC Multiverse, Christopher didn't stay gone forever. He returned within the pages of the *Blue Beetle* series.

Peacemaker is quite the resilient character and has been from the start. Few characters began in the back pages of a canceled series only to reach the pinnacle of pop culture. There is something about Peacemaker that remains relevant through constant change, fighting the good fight back to significance. After making his big-screen debut in *The Suicide Squad* and headlining his very own TV series, Peacemaker has been a presence in the *Suicide Squad* comics. He is no longer an obscure character: instead, he is a beacon to all other characters just waiting for their moment.

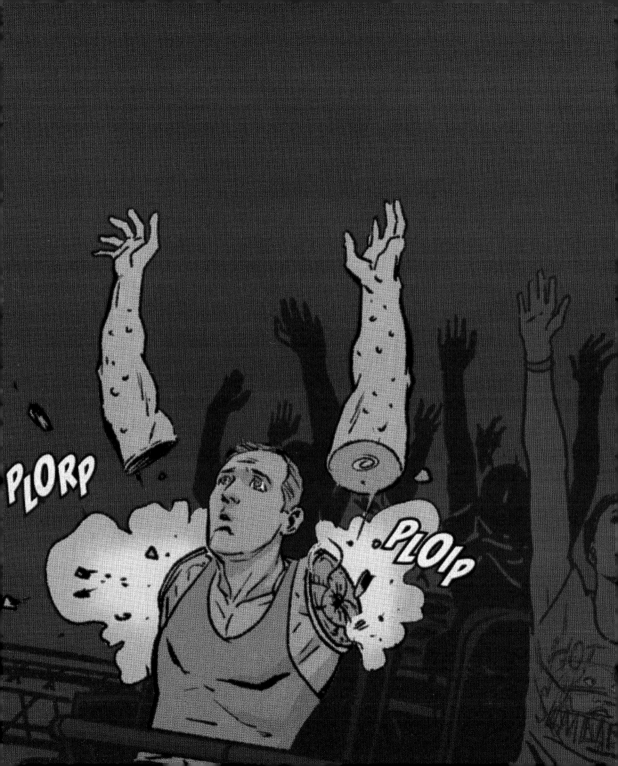

# PARTY TRICKS

**S**OMETIMES YOUR POWERSET ALONE IS ENOUGH TO MAKE PEOPLE REMEMBER YOU (OR EVEN FEAR YOU, DEPENDING ON WHAT YOU'RE TRYING TO ACHIEVE) WHEN YOU'VE GOT A SIGNATURE MOVE. IT'S CLEAR THESE CHARACTERS POSSESS NOVELTIES AND QUIRKS THAT TRANSFORM THE MUNDANE TO THE EXTRAORDINARY. THESE INDIVIDUALS HAVE GIMMICKS THAT RANGE FROM OUTDATED MAGIC TO A WEIRD OBSESSION WITH BEARDS. NO MATTER THEIR SPECIALTY, ALL OF THEM ARE WORTH CELEBRATING FOR WHO THEY SO FIERCELY ARE.

# ABRA KADABRA

FIRST APPEARANCE: *THE FLASH* #128 (MAY 1962)

**A**BRA KADABRA WOULD CONSIDER HIMSELF A CASUALTY of technological advances. The self-proclaimed Master of Magic came to the twentieth century because his craft was no longer relevant in the sixty-fourth. Kindergarteners could perform more complicated magic using the technology in his time. For instance, a disappearing act that once relied on the art of misdirection could be performed using teleportation technology in the sixty-fourth century.

The irony of Abra's plight came when he traveled back to the present. Upon his arrival, Abra began performing magic tricks on the street and still had to use sixty-fourth-century technology to get people to applaud his efforts. So, was Abra truly out of work in his original time period because of technology, or was it simply because he wasn't a very good magician in the first place? These were introspective questions he would never ask himself; instead, he used the money he made from his less-than-stellar street performances to fund his own series of shows.

THEN I'D SAY THAT CALLS FOR AN *ENCORE!*

YES! TODAY, EVERYONE DIES! EVERYONE! THEY'LL ALL GO TOGETHER... AND ABRA KADABRA WILL BRING THEM *BACK* FROM THE DEAD!

When his magic series flopped, it was no surprise that he turned to crime instead. He was no better at crime than he was at magic— The Flash defeated him numerous times. Abra was eventually sent back to the sixty-fourth century and imprisoned, and it's too bad he didn't lean into the performance art of it all. He made a decent escape artist, but he would rather use his energy to force the illusion that he was a great magician than figure out a new skill altogether. After all, what's the point of being from the future when all you wish to do is come to the past?

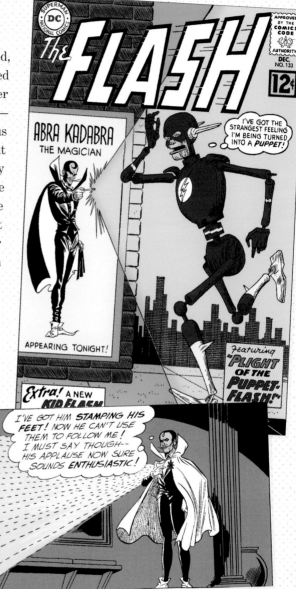

# ANGLE MAN

FIRST APPEARANCE: WONDER WOMAN #62 (NOVEMBER 1953)

**A**NGELO BEND HAD QUITE THE TRAJECTORY IN THE DC MULTIVERSE. He was first introduced as a gangster named "Angles" Andrews in *Wonder Woman* before being reconceived as an inventor who was tired of being disrespected and eager to do something about it. A gangland chief offered him a million dollars to build a machine to get rid of Wonder Woman, and he was quickly accused of wasting the money on the contraption after she defeated him.

Angle Man made several more attempts to defeat Wonder Woman. Too bad taking her out of the equation wasn't as easy as solving the Pythagorean theorem. Despite coming at Wonder Woman from every possible angle, he never succeeded. In fact, Diana made a couple of angle-related puns at his expense, once mentioning she had an angle that would make him a celebrity—but in the prison system, not in the entertainment business. But what kept Angle Man persistent was his greed, something those who hired him to carry out their criminal dealings often dangled in his face.

Angelo wouldn't acquire the Angler, his most prominent weapon, until much later in his criminal career. Scientists on Apokolips created this time-and-space-warping device, which was the perfect contraption for a man who prided himself on being the master of his own fate. Still, even with the Angler, he couldn't defeat Wonder Woman. This version of Angle Man died in *Crisis on Infinite Earths*, but he was reborn as Angelo Bend. Now an Italian master thief for hire, he still couldn't find the right angle to achieve competent Super Villain status.

PARTY TRICKS

# ARM-FALL-OFF BOY

FIRST APPEARANCE: SECRET ORIGINS #46 (DECEMBER 1989)

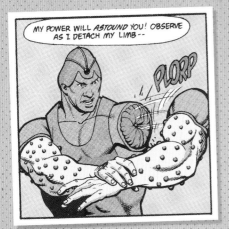

**T**HERE WAS MORE TO THE CHARACTER Arm-Fall-Off Boy than his detachable arms—his legs were detachable too. But if he included the removeable legs in his name, it would've been more complicated than his powers. He made his debut auditioning for the toughest crowd to ever exist in the DC Multiverse, the Legion of Super-Heroes. They were holding the first of their infamous auditions to expand their ranks.

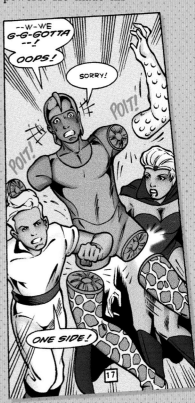

The best Arm-Fall-Off Boy could offer them was the "plorp" sound effect his arm made when detaching. He was confident he made the team as soon as he reattached his arm but was quickly met with awkward silence. With that, he became the first person to officially be rejected by the Legion.

He wasn't seen again until the Legion was rebooted. In the new version of his tryout, he fell to literal pieces and didn't make the cut. His recent appearances in the *Superman's Pal Jimmy Olsen* series leaned into the comedy of his powers, and we learned he came from a family full of people who can detach other parts of their bodies, including their heads.

# BEARD HUNTER

FIRST APPEARANCE: DOOM PATROL #45 (JUNE 1991)

**W**HAT HAPPENS WHEN SOMEONE ALLOWS their pettiness, unpacked baggage, and refusal to take any accountability push them into their villain era? You get Beard Hunter.

Ernest Franklin's hatred for beards grew as the reality sank in that he would never grow his own. So, he did like anyone who had been let down by his hormones would: he declared a personal war on beards and killed his stepfather. His beard rage did not stop there. Ernest soon adopted the alias Beard Hunter and kept on killing men with beards and shaving their dead faces.

Soon enough, his very specific skill set drew the attention of the Bearded Gentlemen's Club of Metropolis that wanted him to assassinate the Doom Patrol's Chief for spurning the club. The thought of aligning himself with a pro-beard organization sickened him, but for the opportunity to kill another bearded man, he took the gig. Things did not go well for Ernest because all he accomplished was dying. Somehow Ernest wound up in heaven, where he lamented not having a weapon after realizing God too had a beard.

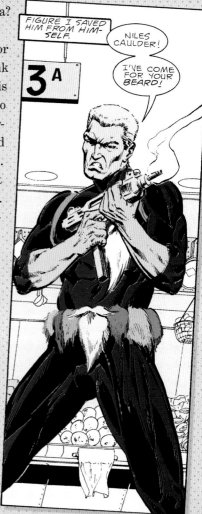

*PARTY TRICKS*

# BLACK RACER

FIRST APPEARANCE: *NEW GODS* #3 (JULY 1971)

**B**LACK RACER WAS A BEAUTIFUL, POETIC MANIFESTATION of death. He represented death as inevitability rather than compassionate release (as depicted by Death, a member of the ethereal Endless family). The Racer's corporeal form was a man named Sgt. Willie Walker who was paralyzed during the Vietnam War. His fate to assume the duties of the Black Racer was, likewise, inevitable.

Willie subconsciously summoned the Black Racer when he thought he was on the brink of death, unable to do anything to prevent it. Instead of collecting William's soul, the Source—the knowledge of all and chooser of those who will carry out the message of death—selected a different fate for him. He joined the pantheon of messengers as the Black Racer.

Donning the Black Racer's armor, William was now free to explore the farthest dimensions. When he was given a mission by the Source, he traveled on skis, with ski poles and a knight's helmet, to collect souls of those whose time was up. The Black Racer's look was a perfect fit for a being whose purpose was to navigate the slopes of inevitability and honor the duties bestowed upon him by the Source. When the Black Racer arrived, he met pleas and bargains for additional time simply with a smile. It wasn't because he didn't care—he had no stake in who lived or died—rather, he was only driven to carry out the inescapable conclusion to their lives.

*STRANGE AND UNSUNG ALL-STARS OF THE DC MULTIVERSE*

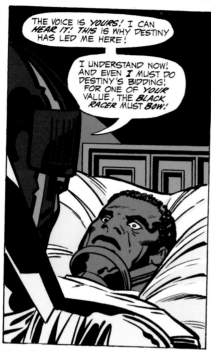

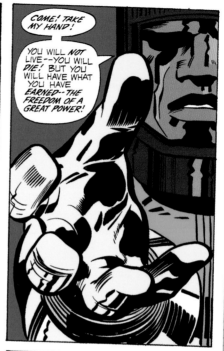

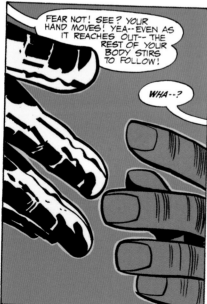

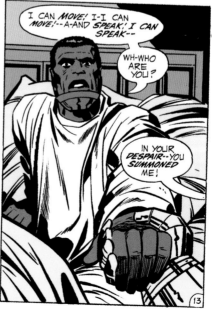

# BRAIN STORM

FIRST APPEARANCE: JUSTICE LEAGUE OF AMERICA #32 (DECEMBER 1964)

**B**RAIN STORM WAS THE SORT OF PERSON WHO WOULD BE greatly affected by Mercury retrograde. The Justice League villain came into his powers after realizing that his most inspired thoughts came when radio-energy emanations from the stars were at their highest. Axel Storm created a helmet to help harness stellar energy to boost his brainstorms and to fire targeted lightning-like blasts.

Axel was dead set on punishing Green Lantern, who he believed killed his brother Fred. Although he saw his brother ensnared by Green Lantern's power ring, Axel didn't realize interference from his own helmet in fact transported his brother to France and erased his memories. To Brain Storm's credit, he had the good idea to disappear after the truth about his brother was revealed.

Brain Storm went on to inflict his big-brain ideas on members of the Justice League and the rest of the world. He once made the entire population of Earth vanish as part of an experiment to harness the radio-frequency emissions of a quasar—an attempt to become more powerful, even before mastering his current abilities. For someone who prided himself on his inspired thoughts, Brain Storm was the embodiment of "just because you can, doesn't mean you should."

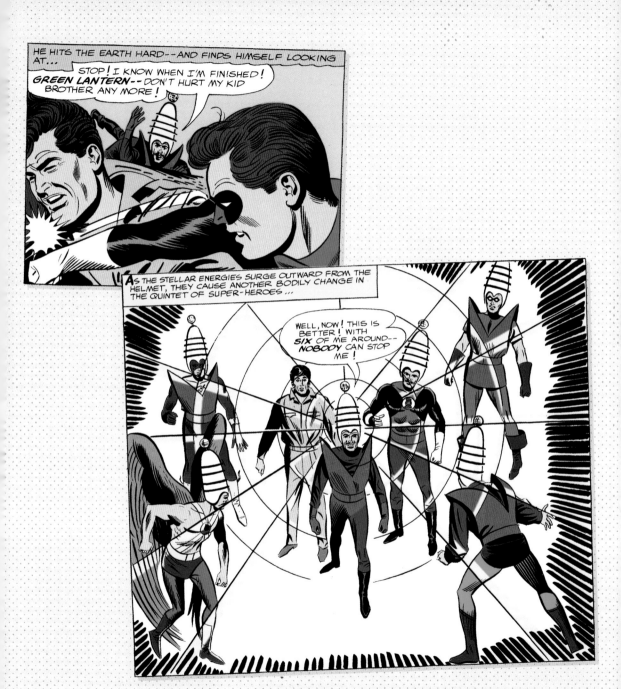

PARTY TRICKS

# CAPTAIN TRIUMPH

FIRST APPEARANCE: CRACK COMICS #27 (JANUARY 1943)

LANCE GALLANT AND HIS TWIN BROTHER Michael were born in New York City back in 1919. They were extremely close, as twins often are. The brothers even had matching T-shaped birthmarks.

Michael enlisted in the US Army Air Corps during World War II and became a pilot. One day after taxiing a new army pursuit plane into a hangar, Michael was killed when the hangar blew up. His death was no accident—both his fiancée, Kim Meredith, and his twin brother, Lance, witnessed some odd activity mere seconds before the explosion: men were running out before their scheduled time to leave. Lance tried to save his brother, but Michael's injuries were fatal, and he died in Lance's arms—on their birthday, no less.

The tragedy prompted Lance to swear vengeance against the murderers and other evildoers of the world. Little did he know his desires were overheard by the mythical beings known as the Fates, who witnessed the entire incident and decided to create a champion.

Soon after, Lance was visited by the ghost of his dead brother, who revealed that they remained linked. When Lance touched his T-shaped birthmark, the brothers could merge, and Lance gained superpowers: invulnerability, flight, invisibility, and shape-shifting. Touching the birthmark again would separate the pair.

STRANGE AND UNSUNG ALL-STARS OF THE DC MULTIVERSE

Lance went on to get revenge against his brother's killers, Baron Von Bragg and his assistant Otto Rotter, and joined the All-Star Squadron after President Roosevelt sent out a call for all Super Heroes. He fought villains like Red Mask and Baron Blitzkrieg before retiring, like most Golden Age heroes, as a new generation began to step up. Lance didn't enjoy retirement for long. In a criminal case, Lance alleged that Michael used his body to kill an old friend's cheating fiancé. He hoped to avoid jail for "his brother's" crime but found himself facing an intense psychological study.

*PARTY TRICKS*

# CONDIMENT KING

FIRST APPEARANCE: *BIRDS OF PREY #37 (JANUARY 2002)*

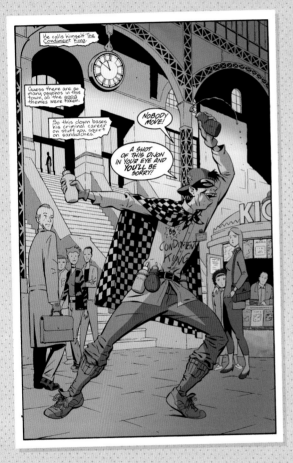

**S**IMILAR TO HARLEY QUINN, Condiment King had the distinction of debuting in another medium before making his way to comic book pages. Like Harley, he first appeared in an episode of *Batman: The Animated Series*, though he hasn't reached Harley's level of acclaim.

Dressed as a waiter at an old-school diner, Mitchell Mayo's first go at criminal activity was as uninspired as the spicy terror of his secret sauce. It took longer to clean up the mess he made than it took for Batgirl and Robin. He didn't get an upgrade to his bland criminality until he met Poison Ivy in prison. With her help, Mitchell boosted his seasoning cabinet and took things to the deranged side of Flavortown. Dressing in a restaurant-inspired Batman suit equipped with a utility belt full of condiments and a weapon to fire them, Mitchell was ready to leave a stain on Gotham City. Too bad he was still no match for a tall glass of milk.

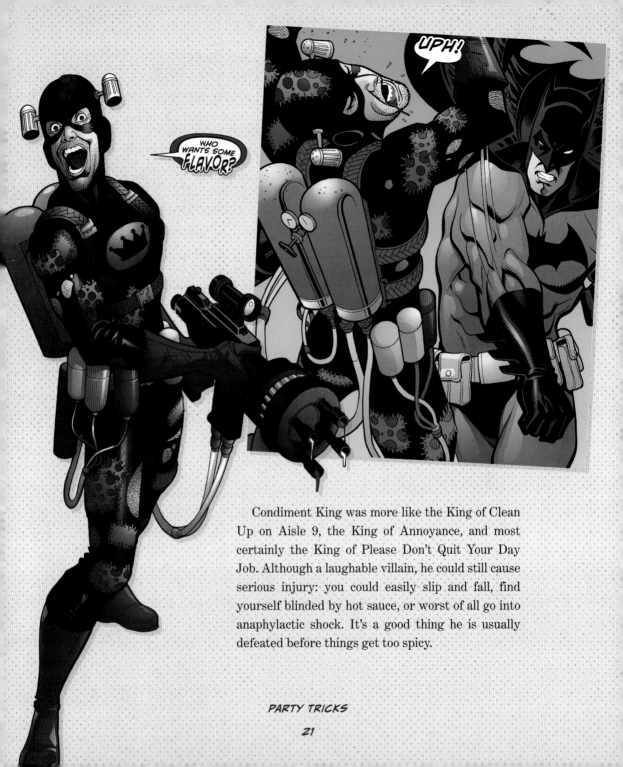

Condiment King was more like the King of Clean Up on Aisle 9, the King of Annoyance, and most certainly the King of Please Don't Quit Your Day Job. Although a laughable villain, he could still cause serious injury: you could easily slip and fall, find yourself blinded by hot sauce, or worst of all go into anaphylactic shock. It's a good thing he is usually defeated before things get too spicy.

# GOLDEN GLIDER

FIRST APPEARANCE: *THE FLASH* #250 (JUNE 1977)

**I**F THE LAST NAME SNART SOUNDS FAMILIAR, it should. Lisa Snart was the younger sister of Leonard Snart, better known as the leader of the villainous Rogues, Captain Cold. They both had a rough upbringing; Lisa endured the same abuse her brother had suffered from their father. She tried to escape her toxic home life as a figure skater who performed under the name Lisa Star for the touring Futura Ice Show. Cold weather themes run deep in this family.

Lisa was a phenomenal figure skater. She could spin at great speed, a skill she learned from her coach and lover, Roscoe Dillon, who also happened to be a foe of The Flash named the Top. It was actually his death fighting The Flash that pushed Lisa into her villain era, making it her life's mission to seek revenge for her boyfriend. Her villain alter ego, Golden Glider, was born. She used skates that produced their own sheets of aerial ice. Yes, that's right—she could skate on air, which should have made her quite the formidable foe.

Golden Glider tried to kill both The Flash and his love interest Iris West but was unsuccessful on every single attempt . . . and there were many of them. It wasn't until Barry Allen died during the *Crisis on Infinite Earths* that Lisa finally renounced her grudge against the speedster and even tried to leave her life of crime. Lisa and Leonard formed the Golden Snowball Recoveries agency, a company with a money-back guarantee on finding lost or stolen items. However, the venture was short-lived, and Lisa returned to being the Golden Glider, a decision that was to her detriment. She was killed by the Super-Villain Chillblaine, who was angry she sold him a faulty copy of her brother's ice gun.

After her death, Golden Glider was one of the many who were resurrected by the Black Lantern rings, though that resurrection proved fleeting. Once reality was recreated in the *New 52* era, she was alive again, and this time not as a reanimated Black Lantern corpse. She became disabled in this reality after battling a brain tumor. Lisa astrally projected herself to gather a new team of Rogues, usurping her brother's command and bringing forth a new era of crime.

# GOLDFACE

FIRST APPEARANCE: GREEN LANTERN #38 (JULY 1965)

**K**EITH KENYON WAS AN ECCENTRIC SCIENTIST WITH A PASSION for deep-sea treasure diving. But he wasn't looking for gold to fund his research—he sought gold with a specific characteristic: it had to have been in contact with seawater for more than a century. He would use a special ultraviolet ray on the saltwater-drenched gold to create an invulnerability elixir.

Keith's exploits put him on Green Lantern Hal Jordan's radar. During a tussle with the hero, Keith drank the gold elixir and, to Hal's surprise, neither his power ring nor his fist had any effect. Keith had the upper hand, but his boastfulness resulted in his defeat. Hal formulated an antiserum spray to dissolve the gold components of the elixir, along with the additional powers it gave Keith. Green Lantern then quickly defeated Keith, but the encounter left Hal wondering whether the elixir truly conferred invulnerability or the gold's coloring triggered the power ring's weakness to yellow.

When Keith encountered Green Lantern again, he stepped up his villain game. Now calling himself Goldface, Keith wore a solid gold suit, sprayed gold mist from a gun, and left personalized signs to get Green Lantern's attention. He was just as flashy as the metal he loved, but it still wasn't enough to best the green hero. Goldface would go on to have several more encounters with Hal. At one point he managed to get Hal arrested on charges of breaking and entering his home. Goldface also had his lawyer

GREEN LANTERN-- GONE ! HE GOT MY GANG ! WORSE THAN THAT-- HE MADE ME LOOK BAD ! BUT I'LL GET HIM YET-- WITH A FATE WORSE THAN DEATH !

present. She provided a court order demanding Green Lantern's arrest for battery along with destruction of private property. The paperwork was all legit, and Green Lantern was sent to jail. Hal didn't spend long behind bars; he escaped after fighting off numerous attacks. Goldface's lawyer made a deal with the court that her client would not press charges against Green Lantern if he didn't harass Goldface again.

Goldface eventually took his gold talents to Central City to start up a crime ring. Because he was in The Flash's neck of the woods, he became a new thorn in the Scarlet Speedster's side, but he eventually turned his life around. When he emerged in Keystone City, Keith rebranded as a union commissioner and led the Keystone Motors employees in their fight against the

company. This change of heart was in direct relation to Keith's desire to follow in his late father's footsteps as an exemplary union leader. Keith secured pay increases and better medical coverage. You could say he still had his golden touch.

# KITE-MAN

## FIRST APPEARANCE: BATMAN #133 (AUGUST 1960)

**A**S MUCH HOT AIR CAME FROM CHARLES BROWN'S BLOATED confidence, it wasn't the source of the air pressure that kept his kites afloat. Kite-Man let his youthful obsession with kites guide him to making kites his adult personality.

Batman and Robin defeated Kite-Man on his very first mission and he quickly found himself in prison. The Rodney Dangerfield of Super-Villains got no respect—either from the heroes he fought or the other villains—and he was beaten to death and eaten by Bruno Mannheim for refusing to join the criminal organization known as Intergang.

When the character was reintroduced in the DC *Rebirth* era, his journey to becoming Kite-Man was far more tragic. Now known as Charles Brown Sr., he adopted the Kite-Man identity after The Riddler killed his son by applying poison to the string of the child's favorite kite.

*STRANGE AND UNSUNG ALL-STARS OF THE DC MULTIVERSE*

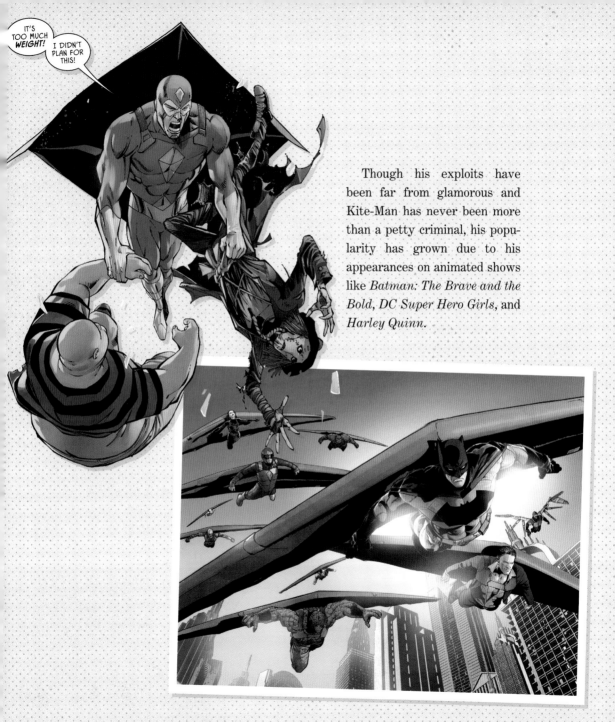

Though his exploits have been far from glamorous and Kite-Man has never been more than a petty criminal, his popularity has grown due to his appearances on animated shows like *Batman: The Brave and the Bold*, *DC Super Hero Girls*, and *Harley Quinn*.

# MATTER-EATER LAD

FIRST APPEARANCE: ADVENTURE COMICS #303 (DECEMBER 1962)

**M**ATTER-EATER LAD HAD A POWER THAT ANYONE OVER THIRTY would greatly appreciate. He could eat anything. He was first introduced as Tenzil Kem, a senator from the planet Bismoll, where microbes had made all their food inedible. In response, the populace evolved to eat all matter.

Unlike other Legionnaire hopefuls, Matter-Eater Lad did not have to try out for a spot in the Legion of Super-Heroes. Instead, he simply wowed them by eating a gun. He then laid out scenarios in which his powers were more than just weird but even advantageous. For example, if they were captured in a jail cell, he could eat their way to freedom.

Shortly after he was sworn in, he immediately proved his worth to the team. Matter-Eater Lad helped fellow Legionnaire Brainiac 5 expose a plan orchestrated by spy pirates to frame their teammate Sun Boy as a spy.

After an uneventful career at the Legion of Super-Heroes, Matter-Eater Lad's time with them was interrupted by a political draft notice calling him back to Bismoll to continue his duties as senator. He later returned to Earth to save both the planet and the Legion from getting devoured by the ever-powerful Miracle Machine. In a dark twist of fate, the alien elements that made up the machine harmed his digestive tract, driving him mad.

Fortunately, Brainiac 5 was eventually able to cure him. With newfound clarity, Matter-Eater Lad rebelled against his duties as senator. He wanted to enjoy his life, and he didn't believe he could do so from a political chair. He became a

multimedia celebrity, using his planet's tax money to fund several television shows, which gave him an excuse to travel back to Earth again. Despite his exploits, he became an even more popular political figure on his home world. Because of his rise in popularity, Matter-Eater Lad was not freed from his political duties until he was transported to a Hades-like dimension by a former Legion villain named Prince Evillo. The opposing political party seized the opportunity to remove him from office by claiming he was technically dead. He was succeeded by his former aide Taryn Loy, appropriately known as the Calorie Queen.

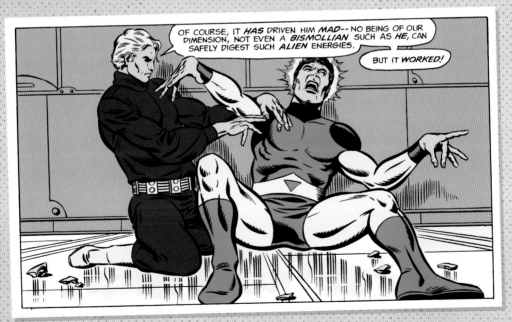

PARTY TRICKS

# MERRY, GIRL OF 1000 GIMMICKS

**FIRST APPEARANCE: STAR-SPANGLED COMICS #81 (JUNE 1948)**

**M**OTHERS HAVE A LIFE TOO. BEFORE Meredith Creamer became Brainwave's mother, she was Merry, Girl of 1000 Gimmicks, and she carried her exploits during her childhood on into her adulthood. Meredith was adopted by the Pemberton family as a playmate for their son Sylvester, who was also known as the Star-Spangled Kid. Once Merry discovered her brother's secret, she took it upon herself to make a costume and join both him and his sidekick Stripesy on one of their crime-fighting excursions. After her brother and Stripesy were defeated by the criminal Presto the Magician, Merry tried her hand at stopping him, but things didn't go as she intended—she attempted to call the police only to discover Presto's trick phone released knock-out gas. Though tied up, Merry still managed to swap Presto's very real gun with a trick one, saving her brother's life when he returned to face Presto.

Sylvester was none the wiser as to who helped him take down Presto. After Stripesy got sidelined with a broken leg, Merry tried to convince her brother she could fill in, but he shot her down. According to him, crime fighting was too tough of a business for a girl. Merry wouldn't be deterred, though. The next time she put on her costume, she defeated the criminal known as the Rope using several different gadgets of her own invention. The Star-Spangled Kid was still reluctant with his praise,

AND MY VEST POCKET NET OUGHT TO SNARE YOU FOR GOOD!

even after discovering Merry was the masked vigilante who captured the Rope.

Merry's life of heroism put her on a path to meet her future husband, Henry King. Unaware he was the Super-Villain Brainwave, Merry fell in love with him, and they got married and had a son, Henry King Jr. But when Henry Sr. was arrested for his crimes, Merry was left to raise the boy alone. Fortunately, he followed in her footsteps as a hero, although he adopted his father's name, Brainwave.

Reports of Merry dying of a broken heart proved incorrect. Back in costume, she was the founding member of Old Justice, a cantankerous bunch of elderly heroes.

# OLD JUSTICE

FIRST APPEARANCE: *YOUNG JUSTICE* #16 (JANUARY 2000)

AGE DIDN'T MELLOW OUT THIS GROUP OF FORMER SIDEKICKS. INSTEAD OF RELAXING IN THEIR TWILIGHT YEARS, THEY BROUGHT OUT THEIR OLD COSTUMES AND SHOWED YOUNG HEROES HOW THE "GREATEST GENERATION" HANDLED THINGS. THEY WERE MET MOSTLY WITH RIDICULE.

*PARTY TRICKS*

# NINA DOWD

FIRST APPEARANCE: *YOUNG JUSTICE* #1 (SEPTEMBER 1998)

**N**INA DOWD'S ORIGIN STORY WAS AN EXCAVATION MISHAP. The mousy scientist was transformed by New Gods technology that she and her colleaguesfound while looking for relics from ancient civilizations.

The eager Nina ignored her coworkers' warnings not to touch the weird-looking device, and she was soon sealed in a crystal cocoon because of her lack of common sense and listening skills. When members of Young Justice arrived to check out what happened, she emerged completely changed. Along with her feline appearance, she was blessed—or rather cursed—with a hypnotizing bust so heavy she couldn't stand upright. The machine made her the first human to be fully transformed into a New God.

Her time as the Mighty Endowed was short-lived. She ended up in custody of the Department of Extranormal Operations (DEO), a government agency in charge of monitoring metahumans, before she could experience whatever level of back pain her new bust would surely bring about.

# RAGDOLL III

FIRST APPEARANCE: VILLAINS UNITED #1 (JULY 2005)

**P**ETER MERKEL JR. WAS THE SON OF THE GOLDEN Age Super-Villain Ragdoll. He didn't inherit his father's double-jointedness, but this didn't mean he had a normal childhood. How could he, with an abusive father who was a sociopath and a cult leader? His father became something of a pop culture icon, dubbed Opal City's Charlie Manson—a petty thug turned killing messiah, who preached his deranged take on life, which amassed him a following.

Despite his father's abuse, Peter still sought out his approval, going so far as surgically replacing his joints with 360-degree sockets. Although he achieved his desire to become a contortionist, he didn't foresee the painful drawback: his skin needed to be lubricated every day to prevent it from splitting.

After years and hundreds of surgeries, Peter achieved a level of flexibility that his father could only dream about. Peter went off to create his own villainous legacy, which led him to becoming a member of the Secret Six, a group run in secret by a disguised Lex Luthor. Peter traded one abusive relationship for another, as Luthor tightly controlled the special emollient Peter needed to keep his bones from tearing through his skin. He spent his time on the team as the resident snark expert, reminding his teammates just how creepy he could be when he used his abilities. As Ragdoll, he often looked like he was playing a game of Twister, wrapping his opponents up in his limbs.

*PARTY TRICKS*

# RON-KARR

FIRST APPEARANCE: ADVENTURE COMICS #314 (NOVEMBER 1963)

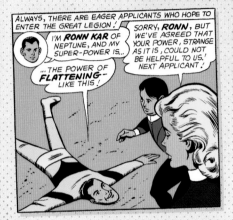

ALWAYS, THERE ARE EAGER APPLICANTS WHO HOPE TO ENTER THE GREAT LEGION!

I'M *RONN KAR* OF NEPTUNE, AND MY SUPER-POWER IS...

...THE POWER OF *FLATTENING*- LIKE THIS!

SORRY, *RONN*, BUT WE'VE AGREED THAT YOUR POWER, STRANGE AS IT IS, COULD NOT BE HELPFUL TO US. NEXT APPLICANT!

**T**HE NEPTUNE NATIVE NEVER WANTED TO be a villain, but he started running with the wrong crowd after his efforts to join the Legion of Super-Heroes fell flat. Literally. Ron-Karr had the power to turn himself two dimensional. Although useful for sliding under doors if he ever locked himself out, its contribution in battle was moot. When the Legion of Super-Heroes rejected him for it, he sought companionship elsewhere. When Tarik the Mute and his Legion of Super-Villains expressed interest, he was happy to join their criminal organization. The group made Ron-Karr the very first student at their newly formed academy.

Unlike his new teammates, Ron-Karr wasn't combative by nature. Though he bragged about his criminal efforts, he typically ran from fights, which alienated him from some of the more sociopathic and bloodthirsty among them. After serving some time and becoming estranged from the Legion of Super-Villains, Ron-Karr found himself joining the ranks of the Legion of Substitute Heroes, which was composed of other Legion of Super-Heroes rejects. He not only stayed on the straight and narrow but also proved himself a hero during the Substitute Heroes' battle against the Dominators. Ron's power made him the perfect person to infiltrate one of the Dominator secret tunnels, which allowed him to access the detonation system they planned to use.

WELL, WELL... THIS "WALL-PAINTING" IS REALLY *RONN KAR*... FLATTENED TO DISGUISE HIMSELF!

NICE WORK, *SUPERBOY!* BUT HOW'D YOU DUCK THAT GLASS-DOOM BIT?

# TATTOOED MAN

FIRST APPEARANCE: *GREEN LANTERN* #23 (SEPTEMBER 1963)

**T**ATTOOS ARE INHERENTLY NONTRANSFERABLE, EXCEPT IN the case of the alias Tattooed Man. Three different characters have used the name, and they are all connected to one another.

The first Tattooed Man was a sailor based out of Coast City by the name of Abel Tarrant. He was in the middle of robbing the payroll safe in a chemical laboratory when he set off the alarm, and the nightwatchman's errant shots caused a chemical spill. Abel was out of bullets himself and began to think about how a bomb would be useful. To his surprise, he manifested an actual bomb from the spilled chemicals. He didn't know it at the time, but the chemicals had the ability to turn thoughts into real things. He used the bomb he brought to life thanks to the chemical to create a diversion and escape.

Although Abel didn't get the money he sought, the chemicals proved much more valuable. No fool, Abel went back to collect more of the liquid and performed a series of tests to confirm his theories about how the chemicals

worked. He didn't go applying the chemical to his skin in the form of tattoos just for the hell of it; he knew exactly what he was doing. Abel was a calculating person, and he put his skills to test once he assumed the name Tattooed Man.

He nearly bested Green Lantern during their first encounter thanks to the yellow hue of his tattoos, but the hero outwitted Abel after discovering he could only use one tattoo at a time. When Abel tried to wield more than one tattoo, his powers became unusable. After his run-in with Green Lantern, Abel went on to live a life of crime and adorned his body with more tattoos.

Eventually he ended up in prison, where he met the second man to take on his criminal persona. Abel's no-nonsense demeanor garnered him a reputation in the yard as the person you respect and don't cross. So, when he stepped in to protect John Oakes, no one questioned it. That fateful day was both a gift and a curse for John. Abel took a liking to him because of the "Born to Lose" tattoo on his arm, and the two began to bond over time. Abel even shared the chemical he used for his special tattoos.

The seventh son of a seventh son, and so on, John Oakes had an affinity for mysticism. This and the shared experience of Abel tattooing him caused him to develop a deep attachment to Abel. John would discover much later that Abel's friendship and the tattoo work came at a hefty price.

When Oakes left prison, he started a new life for himself working as a tattoo artist in San Francisco. He met and fell in love with a woman named Yuko, the granddaughter of Master Kobo, the world's greatest artist in the traditional

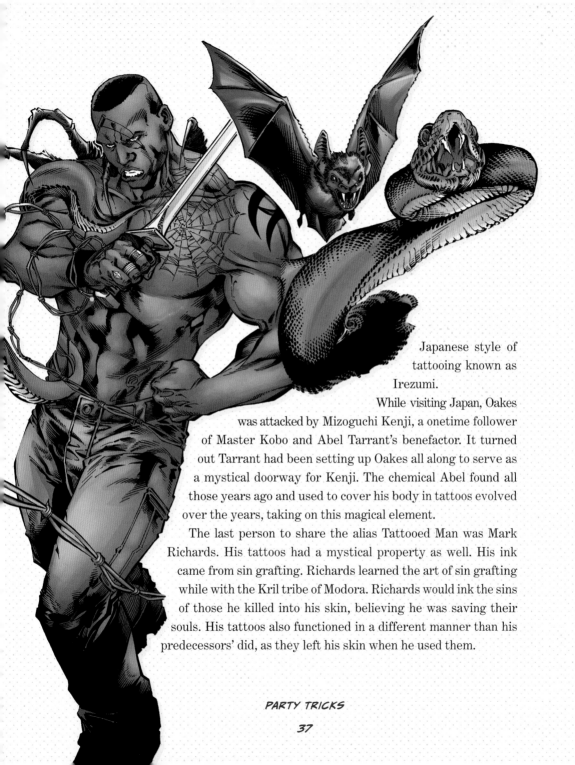

Japanese style of
tattooing known as
Irezumi.

While visiting Japan, Oakes
was attacked by Mizoguchi Kenji, a onetime follower
of Master Kobo and Abel Tarrant's benefactor. It turned
out Tarrant had been setting up Oakes all along to serve as
a mystical doorway for Kenji. The chemical Abel found all
those years ago and used to cover his body in tattoos evolved
over the years, taking on this magical element.

The last person to share the alias Tattooed Man was Mark
Richards. His tattoos had a mystical property as well. His ink
came from sin grafting. Richards learned the art of sin grafting
while with the Kril tribe of Modora. Richards would ink the sins
of those he killed into his skin, believing he was saving their
souls. His tattoos also functioned in a different manner than his
predecessors' did, as they left his skin when he used them.

# MAL DUNCAN

FIRST APPEARANCE: *TEEN TITANS #26 (MARCH/APRIL 1970)*

MALCOM DUNCAN HAS A HISTORY THAT COULD EASILY DOUBLE AS A SUPER HERO AND "BEHIND THE MUSIC" STORY.

AND SUDDENLY...

WHAT A WHACKO DREAM! FIGHTING THE ANGEL OF DEATH --GETTING GABRIEL'S HORN --

HOLY MOTHER--! GABRIEL'S HORN! IT WAS NO DREAM!

**M**AL BECAME A MEMBER OF THE Teen Titans after they helped him in a fight with a street gang named Hell's Hawks. Mal was just trying to protect his kid sister, a very admirable act the Titans appreciated. Although Mal was an official member, he still felt like he was unworthy because of his lack of abilities compared to his teammates. When Dr. Light attacked the team, he didn't even bother with the powerless Mal. Seeing his advantage, Mal slipped into a JLA storage facility to find something to help him rescue his teammates. Mal paired an exoskeleton that enhanced his strength with the suit and shield of the retired Super Hero,

STRANGE AND UNSUNG ALL-STARS OF THE DC MULTIVERSE

the Guardian. Equipped with his new costume, Mal confronted Dr. Light and defeated him. Despite his success while wearing the exoskeleton and Guardian costume, Mal still struggled with his confidence as a member of the Teen Titans. It also didn't help that one of his teammates, Speedy, took the opportunity to joke about Mal's lack of powers.

The second act of Mal's Super Hero journey began when he fought Azrael, the Angel of Death, in what he thought was a hallucination. To his surprise, he awakened in possession of the mystical Horn of Gabriel. The horn granted Mal powers, but at a cost: Azrael placed a curse upon him, so that if Mal ever lost a fight, he would die. Equipped with Gabriel's Horn, Mal summoned his teammates, and together they defeated a gang known as the Wreckers. Afterward, Mal and Speedy finally made nice with one another. With his magical instrument in hand, he tried out a couple of other names—Hornblower and later Herald, in a retconned version of his origin story.

Before Mal debuted his new costume and the Super Hero alias Hornblower, his girlfriend, Dr. Karen Beecher, entered the picture. To make him look better in front of the rest of the Teen Titans, Karen secretly made herself a bumblebee-themed superpowered suit and attacked the team, giving

THE *HAWK'S* COSTUME! THAT GIVES ME AN *IDEA!*

THIS STORAGE AREA IS *LOADED* WITH SOUVENIRS FROM THE TITANS' PAST CASES!

Mal a moment of triumph. After she revealed what she had done, the Titans were impressed and offered her a spot on the team as well. Mal then unveiled his new look and name, which didn't even last for a full comic issue. By the end of *Teen Titans* #49, Mal returned to his Guardian identity. He claimed it was because too many people knew he was the Hornblower after Robin made the announcement, but, in reality, it was because someone had stolen the Horn of Gabriel. Mal and Karen eventually moved west to the new Titans West team. When the group disbanded, the two got married and retired from being Super Heroes for a short while. Mal used the downtime to become an accomplished jazz musician and opened a nightclub, which he named Gabriel's Horn, naturally.

But Mal's story changes altogether post–*Crisis on Infinite Earths*. He never took the identity of Guardian or Hornblower. Instead, he went by the alter ego Herald, and Gabriel's Horn had a completely different origin. In this reality, Mal was an ex–Super Hero who later became a famous musician. Before the career change, Mal accidently freed the villain Gargoyle from Limbo while messing around with a computer program that held plans for a high-tech portal-opening horn. Mal managed to send Gargoyle back to Limbo, or so he thought. Mal then took the plans to Karen, and together they built Gabriel's Horn. So he became the Herald and freed the Teen Titans from Dr. Light using Gabriel's Horn, which allowed him to home in on the captured Titans and bring them through a portal. Later, Mal learned that Gargoyle had manipulated the plans for Gabriel's Horn before Mal sent him back to Limbo, so that whenever he blew it, Mal

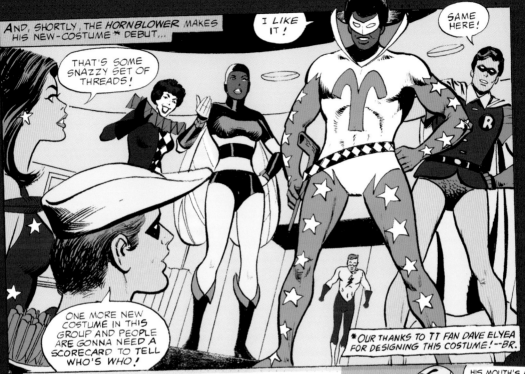

AND, SHORTLY, THE *HORNBLOWER* MAKES HIS NEW-COSTUME ✱ DEBUT...

THAT'S SOME SNAZZY SET OF THREADS!

I LIKE IT!

SAME HERE!

ONE MORE NEW COSTUME IN THIS GROUP AND PEOPLE ARE GONNA NEED A SCORECARD TO TELL WHO'S WHO!

✱ OUR THANKS TO *TT* FAN DAVE ELYEA FOR DESIGNING THIS COSTUME! --BR.

inadvertently opened a portal to Limbo, allowing Gargoyle to escape. Mal managed to recapture Gargoyle and decided to destroy the horn, retiring the alter ego Herald.

Even in this reality, the horn proved to be cursed in another way—it literally blew up in Mal's face when he attempted to open a portal to safety. Pieces of metal from the horn lodged in his chest, and his vocal cords and lungs had to be replaced with circuitry. Mal was left unable to speak, but the dimension-opening horn was now a part of him, and he assumed a new identity, Vox.

HIS MOUTH'S BUSY, ROBIN-- GETTING PUNCHED!

GOOD NIGHT, DR. LIGHT!

MAL DUNCAN

# BAD DAY
# AT WORK

**E**VERYONE IS ENTITLED TO A BAD DAY OR TWO AT WORK. IT HAPPENS TO THE BEST OF US, BUT WE MOVE ON AND THE DAY BECOMES A MEMORY UNTIL THE NEXT ONE COMES. THESE CHARACTERS HAD BAD DAYS WITH FAR MORE IMPACT THAN UNPLEASANT MEMORIES. SOME WERE PHYSICALLY TRANSFORMED, OTHERS WERE SEVERELY MISTREATED BY THEIR EMPLOYERS, AND SOME WERE WHOLLY RESPONSIBLE FOR THEIR DAY GOING COMPLETELY LEFT. NO ONE BAD DAY IS LIKE ANOTHER, AS THESE INDIVIDUALS CAN ATTEST.

# COLONEL COMPUTRON

FIRST APPEARANCE: *THE FLASH* #304 (DECEMBER 1981)

**W**ILL THE REAL COLONEL COMPUTRON PLEASE STAND UP? When the character made their debut, it was a classic whodunit scenario.

Looking like an 8-bit character from an '80s-era video game, the imposing Colonel Computron arrived at the headquarters of the Wiggins Toy Corporation, the makers of a Captain Computron toy, aiming to put founder Willard Wiggins out of business—permanently.

All fingers pointed to the toy inventor Basil Nurblin. His patent for the popular toy was "stolen" by Wiggins, who paid Basil a whopping $99.95 for his microelectronic prowess. Although Basil seemed pretty chill with the check, his wife was livid. She wanted revenge. Like her husband, Francine was also an engineer—an important piece of information because she would be just as capable as her husband of bringing Computron to life. He suspected her just as she would suspect him later on.

When Colonel Computron launched another attack on Wiggins, it seemed that, despite his calm demeanor, Basil was the one in the suit. Perhaps Basil wasn't as spineless as his wife accused him of being. But he and Francine weren't the only Nurblins with a bone to pick with Wiggins. Their daughter Luna also didn't think highly of Wiggins because he robbed her family of money she believed they deserved that would have allowed her to afford to live in a dorm at college. We now had another possible wearer of the Colonel Computron suit.

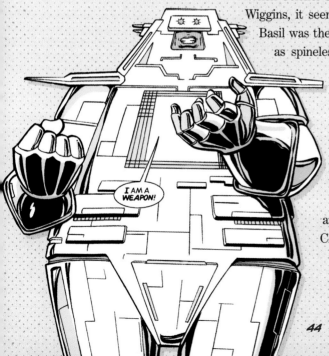

I AM A WEAPON!

Although the mystery of who was behind the attacks on Wiggins remained, Basil eventually opened his own toy store but ran into financial trouble. Luna donned the Colonel Computron costume in a misguided attempt to keep the doors open. But it was then revealed the Colonel Computron suit had its own personality template that could take over anyone who put it on. So, in those earlier appearances, maybe it wasn't any of the Nurblins but the Colonel Computron suit working all on its own. Will we ever know?

BAD DAY AT WORK

# COLONEL FUTURE

FIRST APPEARANCE: SUPERMAN #378 (DECEMBER 1982)

IMAGINE HAVING THE POWER TO SEE THE FUTURE, BUT YOU must have a near-death experience to trigger it. And even after you go through the trouble of almost booking that one-way ticket to the afterlife, you later realize you greatly misinterpreted what you saw in the future. Doesn't that all sound like a fun time? You certainly wouldn't be receiving any invitations to try out for the Legion of Super-Heroes or any variation of the Justice League. For Edmond Hamilton, this was his exact experience as Colonel Future.

Named after real-life science fiction author Edmond Hamilton, our Colonel Future was introduced as a NASA scientist accidently electrocuted after spilling coffee on a control console. This caffeinated jolt showed him precognitive flashes of a huge solar flare destroying the Earth in two weeks.

It's hard to blame Edmond for wanting to act after what he thought he saw. However, his need to be the hero before fully understanding his powers led to two weeks' worth of run-ins with Superman and a bunch of stolen equipment over what turned out to be a huge misunderstanding.

The solar flare was never going to destroy the Earth, and, in fact, it was Edmond's interference that almost caused the cataclysm. Superman caused the flare to destroy an asteroid he discovered was on course to hit the Earth in seventy-five years. Edmond explained to Superman what he had been trying to do as Colonel Future and received a stern lecture about all the trouble he caused.

Colonel Future appeared once more, in *Superman* #399, no wiser than before. This time, his actions almost cost him his own life. He had a premonition of Superman being shot and killed. Instead of taking two minutes to remember that Superman was bulletproof, Hamilton went into Colonel Future mode. Rushing into action based on his assumption, crooks knocked him unconscious and dressed him as Superman. He awoke to a cop pointing a gun at him. Thankfully, Superman arrived on the scene just in time to melt the bullet before it struck Edmond, though this latest brush with death triggered a heart attack rather than another vision. Fortunately, Superman was able to resuscitate Edmond with a superpowered heart massage.

# DR. HELGA JACE

FIRST APPEARANCE: BATMAN AND THE OUTSIDERS #1 (AUGUST 1983)

**D**R. HELGA JACE WAS A scientist who managed to stay out of the unemployment line by being good at her job. She started off working for the royal family of Markovia. As a coup led by Baron Bedlam roiled the kingdom and King Viktor Markov died, Helga attempted to save the castle by injecting the late king's son, Brion Markov, with a serum to give him superpowers like his sister Terra.

Unfortunately, Brion's powers weren't enough, and Helga was taken prisoner. She was rescued by the element-transmuting hero Metamorpho, who needed her knowledge to find a cure for his condition. He was taking a gamble too. Dr. Jace was not known for her bedside manners, but in a surprising display of character growth, she worked toward finding a cure for Metamorpho and even reunited him with his lost love.

Sadly, she would never be able to cure him. In a twist of fate, she did the very opposite.

Dr. Jace became the technical support to the Outsiders. She designed both a headquarters and a jet for the team to use. During the events of *Millennium*, she was discovered to be a sleeper agent for the Manhunters, the original peacekeeping force of the Guardians of the Universe turned would-be universe conquerors. When she was awakened to carry out their plans, she took control of Metamorpho using a psychic chip to attack the Outsiders. Teammate Looker escaped and tricked Metamorpho into attacking Dr. Jace.

Dr. Helga Jace made her return in the DC *Rebirth* era. She was still a scientist from Markovia, but this time she was an astrophysicist forced to work for the evil Kobra Cult until the Suicide Squad saved her.

*BAD DAY AT WORK*

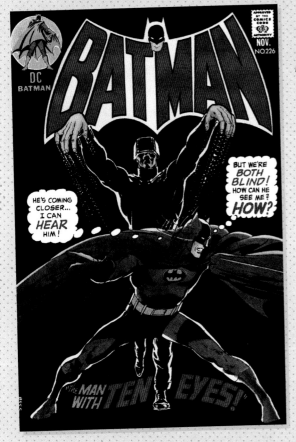

**P**HILIP REARDON'S HISTORY of being in the wrong place at the wrong time put him on the path to become the Batman villain known as the Ten-Eyed Man. The honorably discharged US Special Forces soldier took on a job as a warehouse guard after he was hit between the eyes by a grenade fragment.

Now Philip didn't have a nefarious bone in his body; he just took his duties seriously—a characteristic Batman would have appreciated if he wasn't on the receiving end of it. One night while Philip was standing guard, he was knocked unconscious by thieves, but not before he showed them his hand-to-hand combat prowess. The thieves set a bomb, leaving Philip for dead, and he would have died if Batman hadn't shown up. Philip mistook Batman for one of the thieves and wrestled him to the ground in an attempt to subdue him. The misunderstanding robbed Philip of his remaining eyesight since Batman was tangled up with Philip and unable to prevent the bomb from going off.

Philip blamed Batman for the permanent loss of his eyesight. The moment he received the experimental surgery that allowed him to see through his fingertips, Philip wasted no time seeking his revenge as the Ten-Eyed Man. For what it was worth, Philip gave Batman his best but was unable in both attempts to defeat the Dark Knight. The Ten-Eyed Man's anger was valid, even though it was misplaced. It would be worth it to explore his character beyond misguided vengeance.

# THE TEN-EYED MEN OF THE EMPTY QUARTER

**FIRST APPEARANCE: *52* #30 (JANUARY 2007)**

BATMAN LATER RAN AFOUL OF ANOTHER TEN-EYED THREAT. THE TEN-EYED MEN OF THE EMPTY QUARTER WERE A NOMADIC GROUP OF DEMON HUNTERS WHO WORE BLINDFOLDS AND SAW VIA EYES TATTOOED ON THEIR FINGERS.

*BAD DAY AT WORK*

# BROTHER POWER

FIRST APPEARANCE: BROTHER POWER THE GEEK #1 (OCTOBER 1968)

AT FIRST, BROTHER POWER WAS A MANNEQUIN
ABANDONED IN A TAILORING SHOP THAT LATER BECAME
A HIPPIE HAVEN. ONE DAY, TWO OF THE HIPPIES, NICK
CRANSTON AND PAUL CYMBALIST, DECIDED TO DRESS UP
THE MANNEQUIN IN PAUL'S WET AND BLOODIED CLOTHING
TO KEEP THEM FROM SHRINKING AFTER HE WAS ATTACKED
BY HOUND DAWG, A LOCAL GANG MEMBER. THEY LEFT
FOR THE NIGHT, AND THE MANNEQUIN—STILL DRESSED IN
THE WET AND BLOODIED CLOTHES—WAS STRUCK BY
A BOLT OF LIGHTNING, WHICH BROUGHT IT TO LIFE AND
IMBUED IT WITH SUPERHUMAN ABILITIES.

**S**HORTLY AFTER, BROTHER POWER PUT HIS POWERS TO WORK when the same gang invaded the shop. In return for his trouble, the hippies he helped took him under their wing. They taught him how to talk and then enrolled Brother Power in elementary school, but he felt embarrassed being in class with little kids. Luckily, Brother Power was a quick learner and soon spent most of his time in a science lab. He was obsessed with figuring

out what made him tick, as he was questioning his existence and morality. To keep Brother Power from experiencing an existential crisis, his hippie friends took him out of the lab. In a search of better vibes, they stumbled upon a psychedelic circus parade. The vibes weren't better, as the circus ringleader tried to capture Brother Power, but his friends showed up in time to save him.

Creator Joe Simon intended for Brother Power to be a retelling of Mary Shelley's *Frankenstein*. Unlike his inspiration, Power went on to have some far-out adventures, including running for Congress and being targeted by California governor Ronald Reagan after he and his hippie friends were framed for detonating a missile at the ACME factory where they worked. To escape capture, Power hid away on a rocket, which was subsequently launched into space.

Alas, Brother Power wasn't meant for the stars. Firestorm removed the rocket from orbit, and it crashed in Tampa, Florida. A disoriented Power went on a rampage through the city before a loyal hippie friend, Chester Williams, calmed him down.

Perhaps the wildest interpretation of Brother Power recast him as a magical doll grown from the Tree of Innocence to combat the corrupting influence of the Shadow Tree, a destructive elemental force. When Brother Power left the Tree of Innocence behind for the moving world, it became vulnerable, allowing Dr. Abuse, an agent of the Shadow Tree, to strike. Dr. Abuse enslaved Brother Power and forced him to perform as a circus geek. Brother Power stopped Dr. Abuse, at the cost of destroying his own body. Fortunately he survived by transferring his consciousness into a doll belonging to his old friend Cindy.

Brother Power the Geek appeared again in *The Brave and the Bold* #29. He emerged in a daze from the rubble of a toy store. As he wandered through the streets of Gotham City, Brother Power began to regain both his senses and his memories of leaving his friends behind in the '60s. He thought they betrayed their own beliefs by rioting following the assassinations of Martin Luther King and Bobby Kennedy. He felt just as out of place in the present day and soon sacrificed himself saving a baby from a burning building while Batman rescued the baby's parents. He handed the child to Batman before his body was reduced to ashes, though Batman hoped Brother Power would one day be reborn.

A new incarnation of Brother Power was introduced in 2013's *Green Team: Teen Trillionaires* series. This version possessed telepathic powers as well as the ability to turn humans into dolls. The diabolical Alien Alliance forced him to use this unique doll-making ability on the residents of Dangerfield, Arizona, but he fought back with his strong will and good heart.

# CHEMISTRY 101

CHEMISTRY IS THE STUDY OF MATTER AND ITS PROPERTIES, AS WELL AS HOW AND WHY SUBSTANCES COMBINE OR SEPARATE TO FORM OTHER SUBSTANCES AND INTERACT WITH ENERGY. IT'S AN EXPLORATION OF HOW THE WORLD AROUND US WORKS. FOR THESE CHARACTERS, UNDERSTANDING THEIR CHEMISTRY IS A GREAT WAY TO HIGHLIGHT WHO THEY ARE OR WHAT THEY CAN DO NO MATTER WHAT PHYSICAL STATE THEY'RE IN.

# BEN BOXER

FIRST APPEARANCE: *KAMANDI* #1 (NOVEMBER 1972)

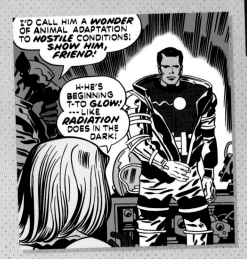

**B**ENJAMIN BOXER APPEARED HUMAN, but he was far from it. He was one of three Nuclear People of Earth-AD, mutants created by scientists to withstand the effects of an event known as the Great Disaster, which would occur in the distant future. Ben had the ability to turn into metal. Once he and his fellow Nuclear People, Steven and Renzi, were able to walk the ocean floor because they could recycle oxygen in their metal forms.

Ben fought against the rule of the Tiger Empire—a race of humanoid tiger-people in the postapocalyptic future. Ben made several comic book appearances in issues featuring the character Kamandi. Ben and his allies aided Kamandi in his struggles to keep Earth alive long enough to rebuild humanity's shattered society. In their adventures together they faced bat-people, seafaring leopards, and even a society of dolphins who trained humans as their squires.

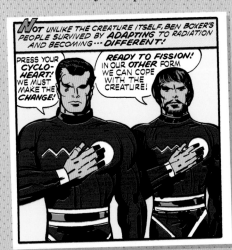

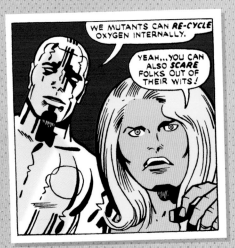

# BLUE ICE

**W**E DIDN'T GET TO SPEND MUCH TIME WITH Blue Ice, but she left enough of an impression that we wish we had more. Blue Ice was introduced in the pages of *Wonder Woman* as a villain with the ability to amplify radioactive elements in other people's blood, killing them.

Blue Ice and her lover Dr. Echo staged an attack on the Las Vegas Strip to bait Wonder Woman into confronting them. The pair left as many as two hundred injured, in an act they claimed was a protest of Wonder Woman meddling in other nations' affairs. Unfortunately for Blue Ice, it was the beginning of her very quick end. Wonder Woman made her appearance and swiftly defeated Blue Ice. After the encounter with Wonder Woman, Blue Ice was whisked away and healed by the demon Ahriman, who offered her power he stole from Ahura-Mazda, the Zoroastrian god of light, to kill Wonder Woman.

Blue Ice got her rematch with Wonder Woman and a bonus guest opponent, Nubia. Nubia attempted to subdue Blue Ice by wrapping her in Diana's Golden Lasso of truth. In a startling twist, Blue Ice burst into flames. The interaction between the lasso and the magic Blue Ice received from Ahriman—in addition to the reveal of overwhelming childhood trauma she suffered at the hands of her father—brought about her untimely death. She confessed that she knew her father secretly hated her and the rest of his family, and that he murdered seven men by exposing them to x-rays while they slept. She also revealed she was put in a lab and studied. She burned herself from the inside out with her own powers.

# CHEMICAL KING

FIRST APPEARANCE: ADVENTURE COMICS #371 (AUGUST 1968)

**C**ONDO ARLIK HAILED FROM THE PLANET PHLON. HE WAS A member of the Legion of Super-Heroes and aptly went by Chemical King because his mutation allowed him to control chemical reactions.

Condo started out as a Legion trainee, and he was very opinionated. He didn't hold back when it came to asking the important questions either. When Brainiac 5 wanted Condo, Superboy, Chameleon Boy, and Timber Wolf to be part of his scheme to infiltrate a villain school, Condo was the one to ask, "Why us?" Because Condo and the others weren't members of the Legion yet, they made perfect decoys. Condo impressed the villain school recruiter by melting a weapon, and upon successfully completing the mission, all four were rewarded with full membership into the Legion of Super-Heroes.

Despite Chemical King showing what a capable hero he was, he still was plagued with self-doubt. Although he wasn't a Legionnaire long enough to cast away those self-deprecating thoughts, he died a hero, sacrificing himself to prevent the shadowy Dark Circle's plans to start World War VII.

# CHEMO

**FIRST APPEARANCE: SHOWCASE #39 (JULY/AUGUST 1962)**

**C**HEMO WAS A WALKING TOXIC WASTE VAT WITH EVIL INTELLIGENCE created by scientist Ramsey Norton, who didn't follow proper waste disposal protocols.

Norton sought to conquer disease, famine, and the ills of humanity but just ended up contributing more harm. Norton clearly was not an avid fan of OSHA because he filled a plastic container shaped like a man with the remnants of his failed experiments. He thought it personified his failures and could serve as a psychological impetus to motivate him to future success. A journal would have been safer and more apt, but Norton had a flair for the dramatic. Chemo finally came to life when Norton disposed of his latest scientific failure—a method to promote uncontrolled plant growth in an effort to combat famine—in the man-shaped container.

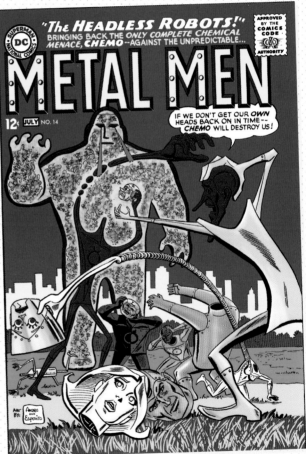

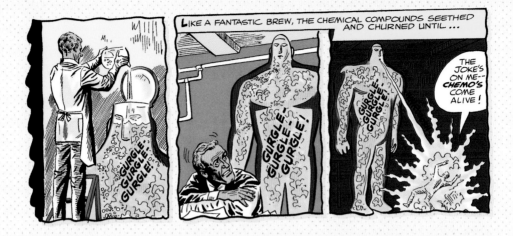

Chemo wasn't completely sentient, but he could control his plastic body, as well as spew a variety of chemical compounds. He once went on a deadly rampage, which led the Metal Men to destroy him. However, Chemo could also resurrect himself, and he continued to be a constant destructive presence in the DC Multiverse.

# MANGA KHAN

FIRST APPEARANCE: JUSTICE LEAGUE INTERNATIONAL #14 (JUNE 1988)

**M**ANGA KHAN CAME ACROSS AS MELODRAMATIC, BUT YOU would too if you were an intergalactic broker who wore a robotic suit with a cape because in your gaseous state you were physically unable to interact with anything. He loved a good monologue, which served him well as both a salesman and an evildoer.

Manga Khan hailed from a planet of gaseous beings who drove a hard bargain. His home world of Pawsteen based its entire culture on a 1626 observation of Peter Minuit trading twenty-four dollars' worth of trinkets for the island of Manhattan. At a young age, Manga got his license to "drive a hard bargain," and his parents immediately traded him for a copy of *BINKY* #1 to a nomadic group called the Cluster. His only real friend was a robot named L-Ron, whom he later traded to the Justice League.

The interstellar salesman chose a humanoid robotic suit because humans were the most gullible and it was easier to swindle them out of their goods for the most insignificant items in return. Manga's first encounter with Earth resulted in

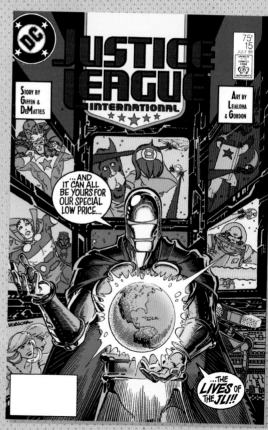

an attack from the Green Lantern G'nort and other members of the Justice League International. The moment it became clear that engaging with the Justice League would be slightly unprofitable, Manga recalled his robots and left, but not before "acquiring" Mister Miracle.

Manga tried to work out what he thought would be a lucrative deal by selling Mister Miracle to Darkseid. He hired Lobo to slow down Miracle's wife, Big Barda, and company, but he was no match for a woman who desperately wanted her man back. Manga almost pulled off one of the biggest deals of his career but instead wound up angering Granny Goodness for leading the Justice League International to Apokolips. Manga was imprisoned but later escaped and continued working his bargain magic across the universe.

# ITTY

FIRST APPEARANCE: *THE FLASH* #238 (DECEMBER 1975)

MANGA KHAN WASN'T THE ONLY MEMBER OF A GASEOUS
SPECIES IN THE UNIVERSE. THERE WAS THE ADORABLE ITTY,
WHOSE METAMORPHOSIS WAS AS RADICAL AS A CATERPILLAR
BECOMING A BUTTERFLY. ITTY BELONGED TO A RACE OF
ALIENS CALLED AYRIES, WHO HAD STARFISH-LIKE PHYSIOLOGY
BUT REQUIRED NEITHER FOOD NOR WATER. THEY POSSESSED
THE INTELLIGENCE OF A GUPPY AND DID NOTHING EXCEPT EXIST IN THE
ATMOSPHERE—A RELATIVELY SWEET LIFE, ALL THINGS IN THE DC MULTIVERSE
CONSIDERED. HAL JORDAN DISCOVERED ITTY WHEN HE HAPPENED UPON
THE VIVARIUM, A GIGANTIC ARTIFICIAL WORLD LEFT BEHIND BY A RACE THAT
EXISTED WELL BEFORE THE EARTH. ITTY TOOK A LIKING TO HAL IMMEDIATELY,
COMMUNICATING WITH HIM SO HE COULD SAVE THE VIVARIUM FROM IMPLODING.

ITTY JOINED HAL ON SOME OF HIS GREEN LANTERN ADVENTURES, AND THE
TWO GREW TO BE AN ODD PAIR BUT GOOD FRIENDS, NONETHELESS. DESPITE
HIS SMALL STATURE, ITTY MADE A GREAT PARTNER. VERY EARLY IN THEIR TIME
TOGETHER, HE PREVENTED HAL FROM HURTING HIMSELF BY ALERTING THE HERO
THAT THE RAVAGER ATTACKING HIM WAS NOTHING MORE THAN A PROJECTION.

EVENTUALLY ITTY MATURED INTO HIS ADULT FORM—A HUGE GAS-LIKE
HUMANOID. HE FLED TO SPACE WHERE HE MET HIS MATE, LASMA. THE TWO
SADLY WERE THE LAST
SURVIVORS OF THE
AYRIES, WHICH PUT A
TARGET ON THEIR BACKS.
THE ALIEN HUNTER LAROO
CAME AFTER THEM, BUT
ITTY'S GOOD FRIEND HAL
WAS MORE THAN WILLING
TO HELP THE COUPLE
DEFEAT HIM.

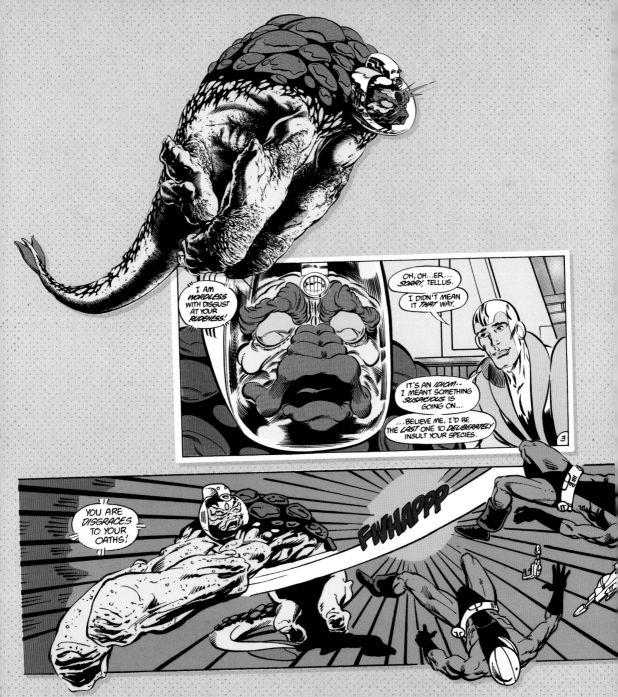

STRANGE AND UNSUNG ALL-STARS OF THE DC MULTIVERSE

# TELLUS

FIRST APPEARANCE: *LEGION OF SUPER-HEROES* #9 (APRIL 1985)

**G**ANGLIOS WAS ONE OF THE MORE PHYSICALLY IMPOSING members of the Legion of Super-Heroes. His home world of Hykraius was a methane-based environment, inhospitable to most but seen as Great Mother Ocean to Hykraians. Ganglios was one of the few Hykraians to leave the planet because he had a desire to experience more.

He worked on an interstellar freighter to raise funds to further his education. It was during his travels he learned about the Legion of Super-Heroes and went to study at the Legion Academy in hopes of starting a similar organization back on his home planet. Ganglios was not a fan of the open-air feel of Earth, and while at the academy, special quarters were created to make him more comfortable. Additionally, Brainiac 5 crafted a special life-support helmet so he could travel freely. Once he finished at the Legion Academy, he assumed the name Tellus and became an official Legionnaire, taking the place of Saturn Girl, who had resigned.

Tellus's telepathic powers allowed him to read minds and send messages across short distances—an extremely helpful way to communicate with his teammates. He also possessed telekinesis and could lift objects or people, as long as they weren't heavier than he. In direct contrast to his large physical form, Tellus was a gentle giant willing to do what was needed to aid his teammates.

# RED TORNADO

FIRST APPEARANCE: ALL-AMERICAN COMICS #3 (JUNE 1939)

ABIGAIL MATHILDA HUNKEL WAS A TRAILBLAZER FOR FEMALE SUPER HEROES IN THE DC MULTIVERSE. SHE WAS FORMIDABLE IN HER ROLE AS THE CAPTAIN OF HER HOUSEHOLD, BUT THEN SHE BECAME THE SUPER HERO RED TORNADO, AN IMPOSING FORCE EVEN WITHOUT THE SUIT.

**M**A WAS NO DAINTY HOUSEWIFE, AND SHE LEANED INTO HER strong appearance. She took on the identity of Red Tornado because local law enforcement was too scared of the local gang to do their jobs. A friend of her son named Scribbly told her about how the Green Lantern wore a mask and costume to save the day without anyone knowing who he was.

Because of her imposing figure, when she was in costume, people automatically assumed Ma was a man. She wouldn't keep her secret for long, when men who

POW

didn't have a heroic bone in their body tried to take credit for what she had done. When the police chief talked himself up like a big hero to the press, Red Tornado burst through the window to confront him. As he tried to have the true hero arrested, she told him to shut his mouth and introduced herself to the masses.

Ma then showed up to the first meeting of the Justice Society. It wasn't all that glamorous, as she accidently tore her costume and wound up pants-less, but it didn't stop her from serving on the team, first as an honorary member and then in a more permanent role. The likes of Liberty Belle, Phantom Lady, and Hippolyta all thought Ma was just another man trying to steal their spotlight. Once she revealed her identity, they welcomed her into the fold, impressed by her commitment to her duties at home and on the team.

Red Tornado eventually gained the Cyclone Kids as sidekicks, and with their help, she defended her city until she retired. Even in retirement and with a brief stint as a mall Santa, Ma didn't lose her desire to stand up to those who tried to harm others. She testified against a gang and was forced to go into witness protection.

ONE SIDE, GIRLS! THE RED TORNADO'S COMING THROUGH!

After all the gang members died, she was able to come out and take the position of curator at the Justice Society Museum.

Ma Hunkel defied norms and pushed boundaries. She was a Super Hero who did not fit the look of her peers and forged a path for characters like Big Barda, who are statuesque and strong.

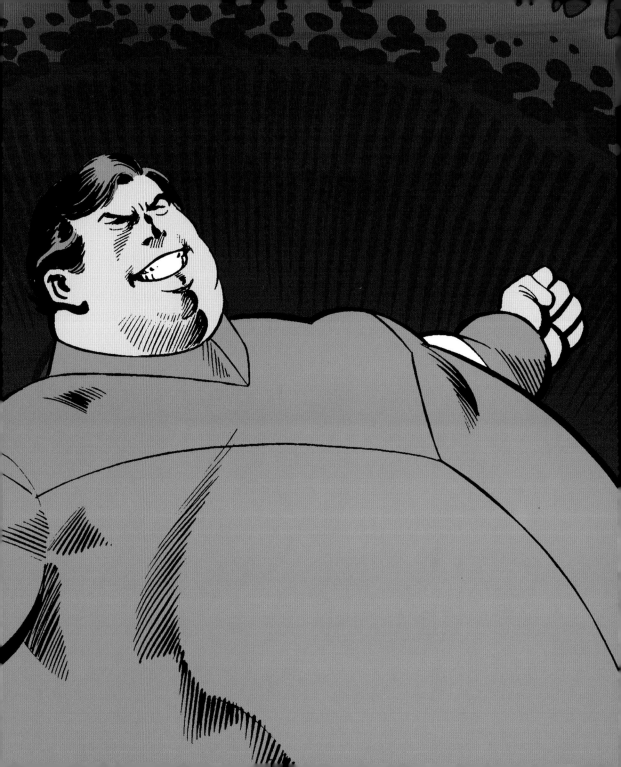

# ROUND,
## OFTEN LARGE,
### AND RARELY IN CHARGE

**T**HESE CHARACTERS ARE ALL PHYSICALLY IMPOSING, BUT THEY TAKE UP SPACE IN DIFFERENT WAYS. SOME OF THEM WANT TO HELP OTHERS, WHILE OTHERS WANT TO BE OBSTACLES. INSTEAD OF SHRINKING THEM, WE HIGHLIGHT THEIR EXISTENCE IN THE DC MULTIVERSE AS THE ROUND, OFTEN LARGE, AND RARELY IN CHARGE.

# BOUNCING BOY

FIRST APPEARANCE: ACTION COMICS #276 (MAY 1961)

**G**OOD THINGS RARELY COME FROM NOT PAYING ATTENTION to what you're doing, but for Charles "Chuck" Taine, carelessness led to a life of heroics.

Chuck was a lab worker in the thirtieth century on Earth, where sports still reigned supreme, or at least they did for him. While at his job—and not on break—he accidently drank an experimental superplastic fluid as he watched a game. The fluid didn't kill him. Instead, his blunder gave him the power to inflate into a spongy, round shape that allowed him to bounce and ricochet around without the need for medical insurance.

It was unclear whether his body inflated like a ball or individual cells expanded, thereby decreasing his overall density while increasing his overall dimensions and making him bouncy. Either way, Chuck's powers were formidable, even if it took a moment for the Legion of Super-Heroes to realize it.

Bouncing Boy was initially rejected by the Legionnaires. It took defeating a robber who used electric weaponry to change their minds. Chuck would be forced to leave the team shortly after losing his powers by jumping in front of a matter-shrinking machine. Thanks to Dr. Zan Orbal, Chuck's powers were restored, and he rejoined the Legion.

With or without his powers, Chuck had a lot to offer personality-wise. He possessed an enormous amount of charm, wit, and good humor. He fell in love with founding Legionnaire Triplicate Girl (later known as Duplicate Girl), and the two eloped on Mars shortly after he proposed. Due to a Legion rule forbidding marriage between members,

*STRANGE AND UNSUNG ALL-STARS OF THE DC MULTIVERSE*

they were both forced into early retirement but returned as reserve members once the unnecessary rule was overturned. They remained one of the shining examples of a happily married couple in the future.

As much as Bouncing Boy enjoyed being a Super Hero, he also took pleasure in training the next crop of them, and he became a teacher at the Legion Academy—a long way from his start as a clumsy lab assistant.

# DR. ZAN ORBAL

**FIRST APPEARANCE: *ADVENTURE COMICS* #351 (DECEMBER 1966)**

THIS RENOWNED GENETICIST WAS THE FIRST SUBJECT OF THE WICKED PRINCE EVILLO'S EXPERIMENTS, WHICH LEFT HIM DISFIGURED. THOUGH ZAN APPEARED TO BE A MEMBER OF EVILLO'S GROUP, THE DEVIL'S DOZEN, HE WAS SECRETLY BIDING HIS TIME UNTIL HE COULD EXACT REVENGE. RETURNING TO THE PRACTICE OF MEDICINE, HE NOT ONLY HELPED BOUNCING BOY BUT WAS RESPONSIBLE FOR REGROWING LIGHTNING LAD'S ARM AND HELPING MATTER-EATER LAD LOSE WEIGHT.

# CHANG TZU

FIRST APPEARANCE: *WONDER WOMAN* #157 (OCTOBER 1965)

**C**HANG TZU HAS HAD SEVERAL DIFFERENT CHARACTERIZATIONS since he first appeared as a Wonder Woman villain named Egg Fu, a characterization that included heavy Asian stereotypes steeped in harmful Yellow Peril propaganda. The giant egg's earlier capers were a bit wild, including turning Wonder Woman's beloved Steve Trevor into a human bomb. Then there was his robot twin, Dr. Yes, who tried to capture Will Magnus by brainwashing the Metal Men.

The character was later reconceived as Chang Tzu, on the island of mad scientists known as Oolong Island. There, he was employed as a weaponsmith by Intergang, a worldwide crime syndicate connected to Apokolips.

Chang Tzu's outer appearance might have appeared fragile, but he was no Humpty Dumpty one would dare to blithely push off a wall. He vaporized a henchman who was foolish enough to laugh at the mention of Egg Fu, which he considered one of 9,009 disgraceful names. He ruled with an iron claw and made sure the scientists he kidnapped to form his Science Squad knew not to get out of line.

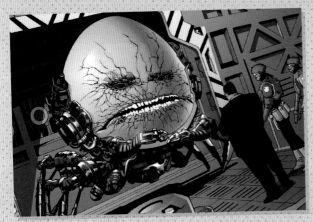

His newest incarnation was Edgar Fullerton Yeung, once again nicknamed Egg Fu. He was a tenant in Harley Quinn's Coney Island apartment building. This incarnation was still a genius, but in a much smaller and gentler form. Although he helped Harley with her exploits from time to time, she still charged him rent.

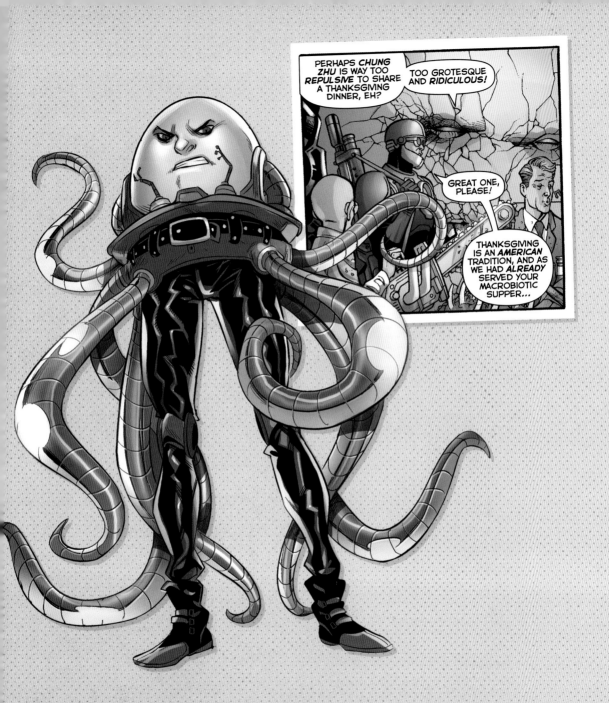

ROUND, OFTEN LARGE, AND RARELY IN CHARGE

# ELU

FIRST APPEARANCE: OMEGA MEN #26 (MAY 1985)

**D**ON'T LET THE APPEARANCE FOOL YOU. LONOCELU osPho, or Elu for short, is one of those characters you can't judge by their look alone.

The energy being from the planet Rogue made quite a first impression. The Omega Men spaceship was under extreme duress due to some acidic space spiders. Since Elu's body was completely covered by an energy field that could withstand a wide range of temperatures, he immediately jumped into action. He had no problem going into the vat of acid in order to drain it from the ship.

The Roguian species were famously shy creatures. The sentient cosmic storms hid themselves—even from each other—by generating a natural force shield shortly after birth. Elu overcame that shyness, venturing away from the planet to study before becoming a freedom fighter with the Omega Men.

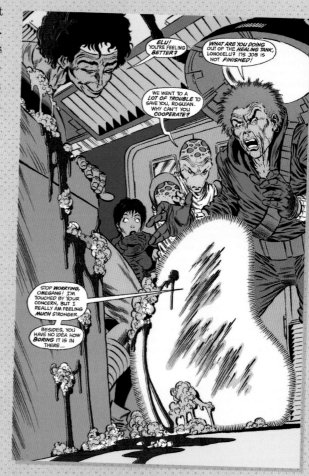

# GLOB

FIRST APPEARANCE: SANDMAN #1 (MARCH 1974)

**A** NIGHTMARE HAILING FROM THE REALM of the Dreaming, Glob was often in the company of fellow nightmare Brute. Contrary to their appearances, Brute was the more intelligent of the two. Glob was more of a schemer than a fighter, but if he had to fight, he would hurl himself at his opponents to smother them.

When Dream, the ruler of the Dreaming, vanished, Glob and Brute set themselves up in a place they called the Dream Stream, located in the unconscious mind of the young Jed Walker.

It was heavily implied that Glob and his associate manipulated Jed's life by influencing his foster parents into beating the child and keeping him imprisoned in horrible living conditions. They also went on to create a fake Sandman using a dead man, Hector Hall. When Dream returned, he destroyed what Glob and Brute had created in his absence and punished them. But good nightmares linger, and Glob had the potential to haunt many more nights in the future.

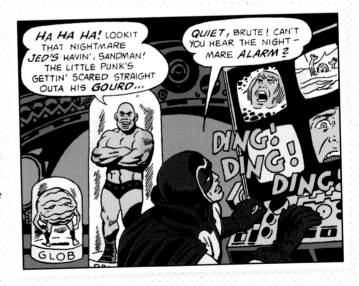

*ROUND, OFTEN LARGE, AND RARELY IN CHARGE*

# GLOMULUS

## FIRST APPEARANCE: GREEN LANTERN #39 (APRIL 2009)

**T**HE ALL-CONSUMING BEING GLOMULUS MADE HIS DEBUT as a member of Larfleeze's villainous and greed-driven Orange Lantern Corps. Before he became an Orange Lantern, Glomulus had a part-time gig as the vacuum cleaner for a tavern owner on the planet Okaara in Sector 2826 of space. One day, before going about his duty eating the scraps of food on the floor, he came across an Okaaran warrior who was itching for a fight and certainly had no plans of leaving a tip. The Okaaran warrior should have sat there and eaten his food, but because he chose not to, he quickly became food for Glomulus. The warrior severely underestimated what he thought was nothing more than an organic vacuum.

After eating his fill, Glomulus wandered into the backwoods looking for something a little sweet for dessert. But in a true circle-of-life moment, Glomulus ended up being someone else's food that day. He crossed paths with an Orange Lantern named Blume, who consumed on the spot. But death wasn't the end of Glomulus. He was reborn as an Orange Lantern himself— quite the glow up apart from having to die.

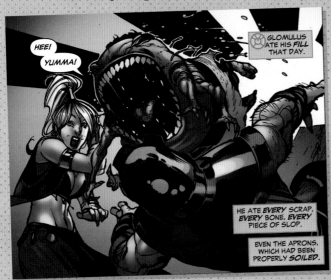

STRANGE AND UNSUNG ALL-STARS OF THE DC MULTIVERSE

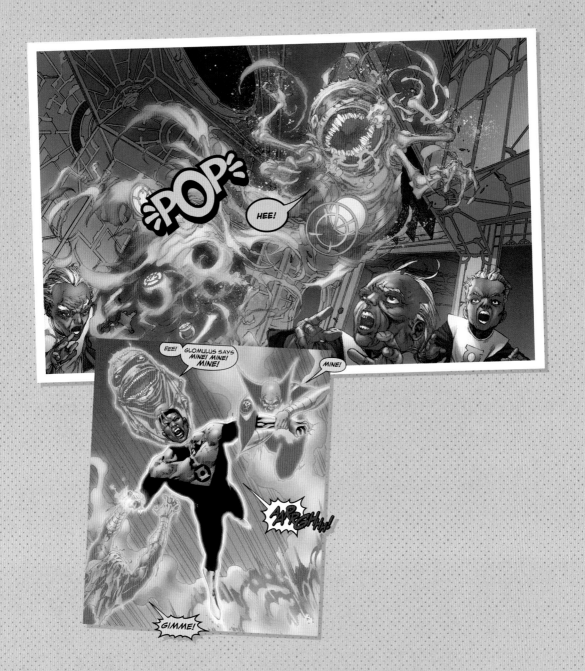

ROUND, OFTEN LARGE, AND RARELY IN CHARGE

# DANNY
## THE STREET

FIRST APPEARANCE: DOOM PATROL #35 (AUGUST 1990)

SINCE THEIR INTRODUCTION, DANNY THE STREET HAS BEEN ONE OF A KIND—A SANCTUARY FOR THOSE IN NEED OF SAFETY FROM A WORLD THAT HAS DISCARDED THEM WITHOUT SO MUCH AS A SECOND THOUGHT. DANNY GRANTED ASYLUM TO THOSE WHO SOUGHT IT AND TREATED THEM TO BOTTOMLESS MIMOSA BRUNCHES, DRAG SHOWS, AND OVERALL LOVE AND CARE. DANNY COMMUNICATED BY FORMING THEIR WORDS OUT OF ANYTHING FROM MANHOLE VAPORS TO THE LETTERS IN SHOP WINDOWS. NO ONE KNEW JUST HOW THIS PLACE OF WONDER CAME INTO EXISTENCE, BUT WHAT THEY DID KNOW IS DANNY WAS A WELL-TRAVELED, SENTIENT, SPACE-WARPING, SHORT, TWO-LANE AVENUE WHO IDENTIFIED AS TRANS AND NONBINARY.

**P**EOPLE OFTEN FEAR WHAT THEY DON'T UNDERSTAND, which made Danny the target of a mysterious governmental organization called the Men from N.O.W.H.E.R.E. They were dedicated to the extermination of eccentricity and difference—which was Danny the Street all the way down to the pavement. The Doom Patrol came to Danny's rescue. In return, when the Doom Patrol wanted Danny to take them somewhere else, the sentient street happily obliged.

Trouble was never too far from the Doom Patrol—they often brought it upon themselves in one way or another. Danny found themselves caught up in an incident Dorothy Spinner caused when she accidently unleashed the Candlemaker, who wreaked a great amount of damage upon Danny. But they made a comeback and even grew into Danny the World. When the Gentrifiers deconstructed them, they became Danny the Brick.

At one point, Danny the Street transformed into Dannyland, a powerful, otherworldly amusement park. Now with the miraculous power to spawn sentient life, Dannyland brought comic character Casey Brinke into existence. This feat put Dannyland on the radar of the evil alien corporation known as Vectra, who wanted to use Danny's powers to produce an endless supply of commodities to sell

as a fast-food chain. Thankfully, the Doom Patrol again came to Danny's rescue.

Recently Danny the Street made their television debut in the live-action *Doom Patrol* series. In the show, Danny was presented in all their glory, a beautiful reminder of what an amazing and impactful character they've always been.

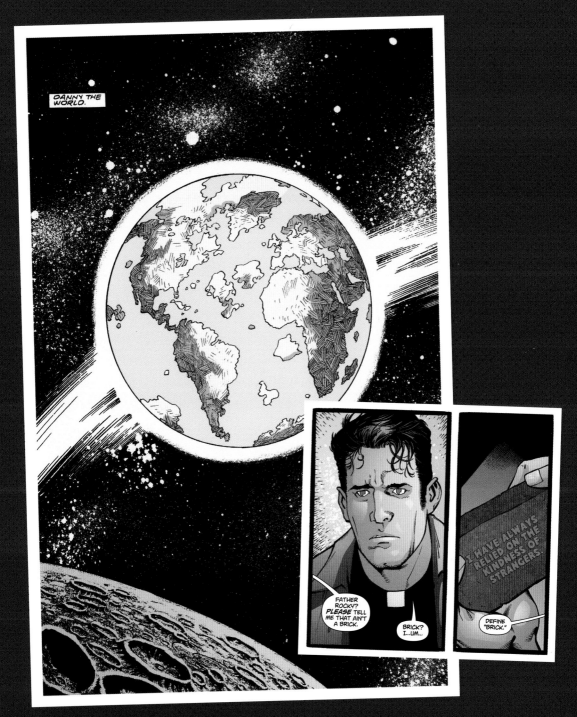

# 9 TO 5 TO CRIME

**S**OME JOBS CAN MAKE YOU WANT TO SCREAM OR, IN THE CASE OF THESE CHARACTERS, GO WILD AND BEGIN COMMITTING CRIMES. OTHER JOBS WERE MERE PLACEHOLDERS FOR CHARACTERS WITH A GOAL UNTIL THEY COULD GO OUT AND BE THE CRIMINALS THEY DESIRED TO BE. WHATEVER THE MOTIVATIONS, EACH HAD A PASSION; THEY JUST WEREN'T IN THE RIGHT LINE OF WORK.

# CRAZY QUILT

## FIRST APPEARANCE: BOY COMMANDOS #15 (MAY/JUNE 1979)

**T**HE ORIGINAL CRAZY QUILT WAS INTRODUCED AS A NOTED painter living a double life as a crime lord who left clues for his henchmen in his paintings. Things were going well for the criminal until he was double-crossed by one of his henchmen. Crazy Quilt was blinded by a gunshot. He had no health insurance, but who needs that when you have underlings to hold an eye surgeon at gunpoint while you undergo an experimental procedure? Exactly.

The helmet Crazy Quilt used in his criminal exploits allowed him to manipulate color, project energy, and hypnotize. The helmet aided him with his visual impairment—the lens that projected lethal laser beams also fed images directly into his brain so that he could see. His quilt, on the contrary, was nothing more than an eyesore.

Years later, Crazy Quilt was reintroduced as Paul Dekker, based out of Gotham City. Blinded by Robin during a fight with the Dynamic Duo, he grew obsessed with exacting revenge on the young hero.

But he was later reconceived as Dr. Paul Dekker, a former Wayne Industries scientist whose family was killed in a gas leak, prompting him to dedicate his life to regenerative science. The Crazy Quilt alias made more sense under this iteration, as Paul invented something called "the healing stitch," which could unravel a cell's structure and then stitch it back together completely de-aged.

# FILM FREAK

## FIRST APPEARANCE: *BATMAN #395 (MAY 1986)*

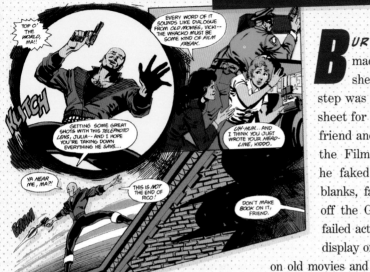

**B**URT WESTON NEVER made it onto anyone's call sheet, so the next logical step was for him to develop a rap sheet for himself. With the help of friend and fellow actor Al Jacobs, the Film Freak was born after he faked his death with staged blanks, false blood, and a plunge off the Gotham Bay Bridge. The failed actor wielded an impressive display of gimmicks, basing crimes on old movies and setting out to get revenge against all he believed had ever wronged him.

True to his nature, Film Freak got a sequel as a late-night TV host known only as Edison, who similarly carried out classic-film-based crimes, going so far as nearly nuking Gotham City in an homage to *Dr. Strangelove.*

# MAD MOD

FIRST APPEARANCE: *TEEN TITANS #7* (JANUARY/FEBRUARY 1967)

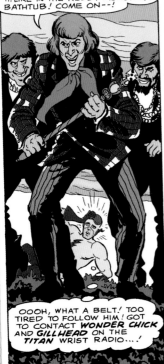

WELL NOW! I UNDERESTIMATED THAT LIGHTFOOT LAD-- 'E FOUND THE TREASURABLE TRINKET! *MOD* WILL 'AVE TO 'IDE IT ELSEWHERE ...LIKE IN THE RUDDY MONSTER'S BATHTUB! COME ON--!

OOOH, WHAT A BELT! TOO TIRED TO FOLLOW HIM! GOT TO CONTACT *WONDER CHICK* AND *GILLHEAD* ON THE *TITAN* WRIST RADIO....!

**N**EIL RICHARDS WAS ONE OF THE FIRST villains the newly formed Teen Titans had to face. He was introduced as a Carnaby Street fashion designer. With an alias derived from the mod style popular in England at the time, he possessed no superpowers but used fashion as a front to smuggle goods by incorporating them into the fabric of the clothing. After serving time, Neil's life came full circle when he was hired to design the costumes for a new incarnation of the Teen Titans. Neil found himself on par with other designers in the DC Multiverse. Most recently, Mad Mod was spotted sporting a handlebar mustache and a slick haircut. He was a member of a clandestine group called Diablo, who sought to protect the planet from alien threats at all costs, even killing Super Heroes if they got in the way.

AND INSIDE THE SHOP...

HERE'S THE LOT, *MOD!*

DUCKIES, THE GOODIES 'AVE ARRIVED! NOW LET US SEE WHAT MY NEW YORK BRANCH 'AS CLEVERLY, CUNNINGLY CONCEALED IN THE GEAR THREADS OF MY MERELY MAGNIFICENT CREATIONS! PUT IT IN THE FLUOROSCOPE!

AHA, MY

# MOD GORILLA BOSS

FIRST APPEARANCE: *STRANGE ADVENTURES* #201 (JUNE 1967)

THE MOD SCENE CONTINUED WITH MOD GORILLA BOSS, A PRIMATE WITH A CHIP ON HIS SHOULDER, WHO PUT ANIMAL MAN ON NOTICE REGARDING WHO WAS BOSS IN THE HUMAN WORLD. THE TALKING GORILLA, WHO RAN HIS GANG AND WORE A PINSTRIPED SUIT, WASN'T REALLY A GORILLA AT ALL. HIS TRANSFORMATION WAS DUE TO A SPECIAL SERUM HE CREATED TO KEEP UP WITH HIS MONKEY BUSINESS.

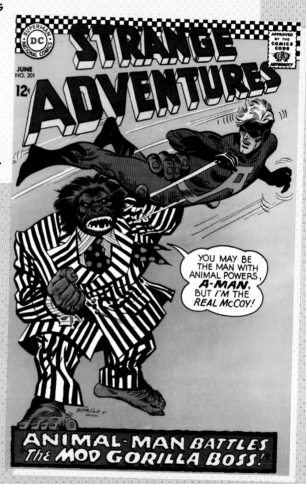

9 TO 5 TO CRIME

# MAXIE ZEUS

FIRST APPEARANCE: DETECTIVE COMICS #483 (MAY 1979)

**M**AXIMILLIAN ZEUS WAS A GREEK HISTORY PROFESSOR driven mad by unknown causes. In turn, he became one of the most popular and successful gang leaders in Gotham City.

He convinced himself he was the incarnation of the Greek god Zeus. He planned all his crimes around mythological motifs and spoke as if he were in a Shakespearean play. Maxie assembled a group of Super-Villains modeled on mythological gods, calling them the New Olympians. All of this was in an effort to coerce a Greek athlete to adopt his daughter Medea. When that plan didn't pan out, he tried to kidnap Olympic athlete Lacinia Nitocris and force her to marry him and become his daughter's stepmother.

Maxie spent a good amount of time in and out of Arkham Asylum. His obsession with Greek mythology got him roped into a plan engineered by Deimos, Phobos, and Eris, the children of Ares, the god of war. They wished to merge Gotham City with Ares's throne capital, known as the Areopagus, to reestablish Ares's rule on Earth. Maxie led the group of gold mask wearers, asserting that he was Ares's most devout follower and would be rewarded by the god himself once he was put back in charge. He sacrificed himself to Ananke, the goddess of fate, to bring on the merger, but ultimately Wonder Woman set things right.

# VELVET TIGER

FIRST APPEARANCE: DETECTIVE COMICS #518 (SEPTEMBER 1982)

**L**ANI GILBERT WAS A SPECIALIST IN BLACKMAIL AND rocking tiger print. She had no desire for a career in fashion; instead, she wanted to pursue greater ambitions in the criminal underworld. Lani's powers involved temporal distortion, which gave her the ability to step between seconds in time, effectively resembling super-speed. She achieved fame and wealth as co-owner of Gotham City's Gilcom, a multinational computer hardware manufacturer, with her brother Ward. During this time, Lani opened up to the idea of using computers to access other people's systems to gain access to whatever secrets they kept digitally. She was a hacker at heart. Eventually, she started using the information she obtained on others to build a criminal career as an extortionist.

Barbara Gordon once said Lani was "manipulative and arrogant and doesn't respect anything but her own whims." It's safe to say she was not a favorite of Barbara's, or Hawk and Dove's, whom she also fought in her quest for criminal dominance.

*9 TO 5 TO CRIME*

# MIA "MAPS" MIZOGUCHI

FIRST APPEARANCE: *GOTHAM ACADEMY* #1 (DECEMBER 2014)

MIA "MAPS" MIZOGUCHI HAS A WHILE BEFORE SHE'S INDUCTED INTO THE DC MULTIVERSE DETECTIVE HALL OF FAME, BUT SHE'S WELL ON HER WAY, DESPITE HER NOT-SO-STELLAR GRADES.

**T**HE INQUISITIVE AND HIGH-ENERGY Gotham Academy student was the youngest child of a wealthy family who were acquainted with none other than Bruce Wayne, and Maps just so happened to be a huge fan of his alter ego, Batman. Once she snuck into the GCPD precinct to activate the Bat-Signal in hopes of proving herself to her hero, but she fell asleep waiting for him. Batman was kind enough to return Maps to her dorm room and sign a drawing she had made of the two of them.

In Maps's first year at Gotham Academy, she reconnected with her best friend, Olive Silverlock, who also happened to be her older brother Kyle's girlfriend. It didn't take long for Maps and Olive to lean into what they did best—being nosy. Together the besties, along with Pomeline Fritch (a bully of Olive's) and lock-picking expert Colton Rivera, decided to investigate reports of ghosts on campus. The students eventually uncovered the source of the ghostly happenings: none other than Killer Croc. With their first mystery solved and Croc escorted back to Arkham Asylum by Batman, Maps decided to form a secret Detective Club to investigate the connection between the asylum and the school.

Despite her knack for piecing together clues, Maps was still only a teenager. Unlike the flock of Robins she aspired to join one day, she wasn't trained by Batman, which put her at risk in sticky situations. During the "We Are Robin" movement, when teens took to the streets to protect Gotham City, Maps's ambition almost got her in serious trouble. The movement was outlawed, and any Gotham Academy students found participating were up for immediate dismissal. Had it not been for Olive reporting the prominent movement leader to authorities, Maps could have gotten herself kicked out of school. It took Damian Wayne explaining to Maps why Olive was justified in doing so, as she was only looking out for her friend.

One holiday season, Maps's biggest wish finally came true—she got to work alongside Batman as a Robin—when a Gotham Academy student went missing and body parts reportedly were washing up on the shores of Gotham River. Against Batman's wishes, Maps helped him locate the missing student and deal with a horde of *kappa* (reptilian creatures of Japanese folklore). Despite having to be saved by Batman—and receiving a stern lecture from him—Maps remained hopeful of one day officially becoming a Robin.

MIA "MAPS" MIZOGUCHI

# HAIR VIBES

**H**AIR CAN BE A STATEMENT ABOUT WHO YOU ARE AS AN INDIVIDUAL. A SIGNATURE HAIRSTYLE CAN ENSURE THAT PEOPLE KNOW WHO YOU ARE BEFORE THEY EVEN BOTHER TO LOOK AT WHAT YOU'RE WEARING. FOR THESE CHARACTERS, THEIR HAIR ISN'T JUST A FASHION STATEMENT; FOR SOME, IT IS THEIR GREATEST STRENGTH, QUITE LITERALLY.

# MAGPIE

FIRST APPEARANCE: MAN OF STEEL #3 (NOVEMBER 1986)

**M**ARGARET PYE WAS A KLEPTOMANIAC, HENCHMEN-KILLING, delusional jewel thief who had the honor of being the first villain Batman and Superman teamed up to defeat in DC's post-*Crisis* era. With her manic hair and frantic mannerisms, infatuation with sparkling artifacts drove her to a life of crime, and she assumed the name Magpie (though, funny enough, real magpies don't actually steal shiny objects; they were smeared by Rossini's 1815 opera, *The Thieving Magpie*).

As curator of the Gotham City Museum of Antiquities, Margaret soon became overwhelmed with thoughts of stealing the museum's precious objects to keep all to herself. Magpie made her thieving debut by stealing from the museum and leaving booby-trapped duplicates behind—punishment, in her mind, for people keeping these objects from her.

Magpie has died twice now. First, she was caught up in a criminal turf war between The Penguin and Great White Shark, but that death was undone with changes to reality. Following a subsequent arrest, Magpie found herself incarcerated in Belle Reve and forced to join the Suicide Squad.

BEAUTIFUL, BEAUTIFUL SPARKLY THING-- *YOU'RE MINE!*

*HAIR VIBES*

# MINDBOGGLER

FIRST APPEARANCE: *THE FURY OF FIRESTORM* #29 (NOVEMBER 1984)

**L**EAH WASSERMAN AND HER INCREDIBLE PUNK-ROCK LOOK were already dizzying, but her illusion-casting powers—received from the superpowers-for-a-price Assassination Bureau—were truly mindboggling. In her debut against Firestorm, Mindboggler cast the illusion of an active volcano in the middle of Central Park. Her mind games continued as she manipulated Firestorm into thinking he was using his own powers to turn the nonexistent lava and ash into harmless flying discs, when in fact he was raining down razor blades on innocent parkgoers, who assumed the hero had gone berserk.

THEN... THERE'S NO *LIMIT* TO WHAT I CAN DO! I CAN MAKE ANYONE SEE AND HEAR THINGS THAT AREN'T THERE! I DID IT TO THE PARK'S PASSERSBY... AND EVEN TO THE NUCLEAR MAN!

I TRULY AM... THE *MINDBOGGLER!*

Like Magpie, Leah eventually found herself on one of Amanda Waller's Suicide Squad teams, where she was betrayed by one of her own teammates. She used her powers to embarrass Captain Boomerang after he sexually harassed fellow teammate Plastique. In retaliation, since Captain Boomerang was a sorry excuse for a person, he decided not to intervene as Leah was about to be gunned down on a mission, allowing her to die because she had the audacity to stand up to him. This act of selflessness and community that Leah displayed made her a character who stood for something, even when her outer appearances of punk-rock apathy suggested she didn't want to be bothered with anyone at all.

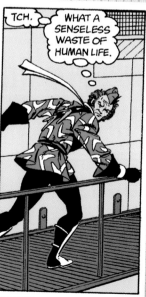

HAIR VIBES

# SPIDER GIRL

## FIRST APPEARANCE: ADVENTURE COMICS #323 (AUGUST 1964)

**S**USSA PAKA WAS AN EARTHLING IN THE THIRTIETH CENTURY recruited to take part in a mutagenic experiment, which granted her the ability to control her hair. Sussa opted to go by Spider Girl because her hair could expand into a web to entrap foes. Though the name was provocative, her later alias Wave was the better fit.

Sussa was an instrumental part of a campaign by the female aristocracy of the planet Taltar to have a stronger influence on the United Planets via a matriarchal coup. Sussa decided to take matters into her own hair and find more productive things to do than fight men. She quickly applied for membership in the Legion of Super-Heroes but wasn't accepted because her hair powers were a bit out of control and nearly strangled some other Legionnaires. Sussa went on to join the Legion of Super-Villains, who welcomed her and her mischievous mane.

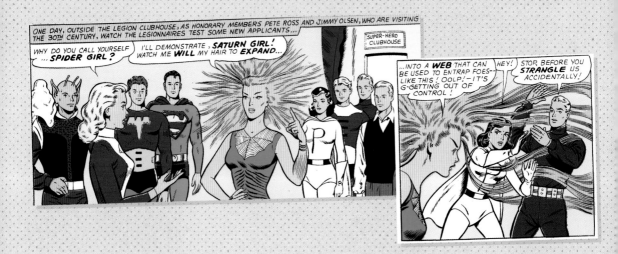

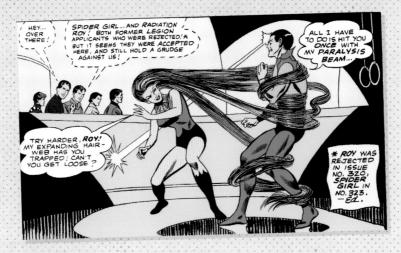

Despite starting as a petty thief just trying to get by and becoming a full-blown villain, she flirted with both heroics and her teammates when she dyed her hair blue and joined the Legion of Super-Heroes as Wave. She couldn't quite leave villainy behind, eventually joining up with the xenophobic Justice League of Earth, which consisted of other Legion rejects.

# GODIVA

**FIRST APPEARANCE:** *CRISIS ON INFINITE EARTHS #12 (MARCH 1986)*

DORCAS LEIGH, A MEMBER OF THE GLOBAL GUARDIANS (SEE PAGE 153) COULD LENGTHEN HER HAIR AND CAUSE IT TO TAKE ANY SHAPE AS WELL AS HARDEN. THIS POWER WAS ENOUGH TO MAKE HER GREAT BRITAIN'S PREMIERE SUPER HERO.

# KING SHARK

FIRST APPEARANCE: SUPERBOY #0 (OCTOBER 1994)

IF YOU COME FOR THE KING, YOU BEST NOT MISS. IF YOU DO, YOU MIGHT AS WELL CONSIDER YOURSELF SEAFOOD FOR THE SON OF THE SHARK GOD. NANAUE, BETTER KNOWN AS KING SHARK, WAS BORN IN THE PACIFIC OCEAN OFF THE COAST OF HAWAII.

BEFORE KING SHARK BECAME THE FEARSOME ANTIHERO he is known as today, he was the apex predator with an ominous, toothy smile who even ate pieces of his mother (she allowed it, for sustenance). Nanaue first landed on Superboy's radar after a special agent tracked the beast to Hawaii. Superboy managed to apprehend Nanaue, but he didn't spend long locked away. In fact, when he was freed by the vicious criminal organization known as the Silicon Dragons that dominated the Hawaiian Islands, he taught them a lesson in humility. They assumed he would work for them, but instead he ate them.

Like many incarcerated villains in the DC Multiverse, Nanaue was eventually assigned to the Suicide Squad. His first mission with them was to destroy what was left of the Silicon Dragons. Nanaue went on to join other teams, like the Legion of Super-Villains and Secret Society of Super-Villains. With the Secret Society he attacked another team that would be in his future, the Secret Six.

After the reality-reshaping events of *Infinite Crisis*, Nanaue's origin story changed, but what made King Shark the beloved antihero we know today remained the same. He was still the son of the shark god and a person heavily sought after by others to be used for their own advantage—even those who wouldn't be considered villains, like Aquaman. The constant battle to live his life as he saw fit has opened the character up for deeper exploration in his post–*Infinite Crisis* appearances.

In his reemergence, Nanaue was introduced as a friend and mentor to the new Aquaman at the time, Arthur Joseph Curry. He was no longer as violent, and he talked much more because he had a reason to—granting readers more insight into how he felt than the animalistic anger we saw his previous incarnation express. For instance, his conversations with Arthur show how seriously he took his role as mentor. Nanaue wanted to do for Arthur what the former King Shark had done for him.

King Shark disappeared again after his time with Aquaman, and when he resurfaced, he was back to swimming in the ocean of villainy. He participated in an attack on the Secret Six put together by Jervis Tetch but then later joined the new Secret Six team. He remained with the team

I'M A *&^%‡#@ SHARRRRRRRRK!

until DC relaunched in 2011. Now, he had a completely different appearance: instead of a great white, he resembled a hammerhead shark, a look he didn't keep for long.

In later stories, King Shark capably ran a team of his own. During his time in San Francisco, he assisted the Nautical Enforcement of Macrocosmic Order and freed several dozen prisoners from Alcatraz, transforming them into sharks. King Shark and his crew eventually caught the attention of the Teen Titans, who drove him away from the San Francisco area for good.

Most recently, King Shark started to take more control of his life. Instead of being coerced into joining a cause, he was asked. He agreed to help Aquaman save Atlantis from the tyrant Corum

Rath out of a desire to keep his community safe when he could have just looked out for himself. No longer was he the selfish son of the shark god; he evolved into the protector of those in need. This evolution continued when he befriended a fellow Belle Reve inmate, Shawn Tsang, also known as the Defacer. He and Shawn found a commonality in their desire to be accepted for who they were and not what others wanted them to be. Through their friendship, we get to see King Shark in all his vicious glory but also at his most vulnerable. At the end of the day, he was someone who desperately wanted his father's love and attention.

# LEANING INTO THE ANIMAL KINGDOM

**T**HE ANIMAL KINGDOM CAN BE AS VAST AND DIVERSE AS SPACE ITSELF; IN THE DC MULTIVERSE, IT'S NO DIFFERENT. THESE CHARACTERS ARE JUST AS UNIQUE AS THEY ARE STRANGE, AND THEY ALL HAVE SOME RELATIONSHIP TO ANIMALS, IF THEY AREN'T ANIMALS THEMSELVES. SOME ARE CUTE AND CUDDLY, WHILE OTHERS ARE AS FEARSOME AS THEY COME, BUT TIME SPENT ON THE WILD SIDE WITH THEM IS WORTH IT.

# AMBUSH BUG

FIRST APPEARANCE: DC COMICS PRESENTS #52 (DECEMBER 1982)

**A**MBUSH BUG HAS A BIT OF AN INTERESTING ORIGIN STORY, if you can believe it, which could be difficult as it's told by an unreliable narrator. An alien named Brum-El from the planet Schwab decided not to forward a chain letter, dooming his planet much like the letter's previous recipient—Jor-El of Krypton. A man of great style, Brum-El decided to send his prized wardrobe, rather than his wife or son, into space to survive the planet's impending destruction. While in space, the ship carrying his clothes was bitten by a giant radioactive space spider, and only pieces from his wardrobe survived crash-landing on Earth—the Ambush Bug suit and an argyle sock named Argh!Yle! An introvert named Irwin Schwab who had been raised on television found the suit but left the sock behind.

Inspired by a comic book starring Lois Lane, Irwin wished that he too could have a comic book life. And when he put on the suit, that's exactly what happened. As Ambush Bug, he started off as a villain, though he really was more of a nuisance than an actual threat to the likes of Superman and the Doom Patrol. But when he fancied himself Superman's friend, the Man of Steel was even more annoyed.

Aware that he was a comic book character, Ambush Bug had adventures that defied traditional Super Hero narratives. The focus of his first limited series was finding guest stars for the book (he got rejected each time). In the second miniseries, he fell out of favor with the book's editors and was forced to make do with no funding. He would also cross paths with Argh!Yle!, who resented being left behind and wore a metal mask to hide the damage from being mauled by a cat. If Ambush Bug wasn't there to explain to readers what was going on . . . we would still be confused, but perhaps not as much.

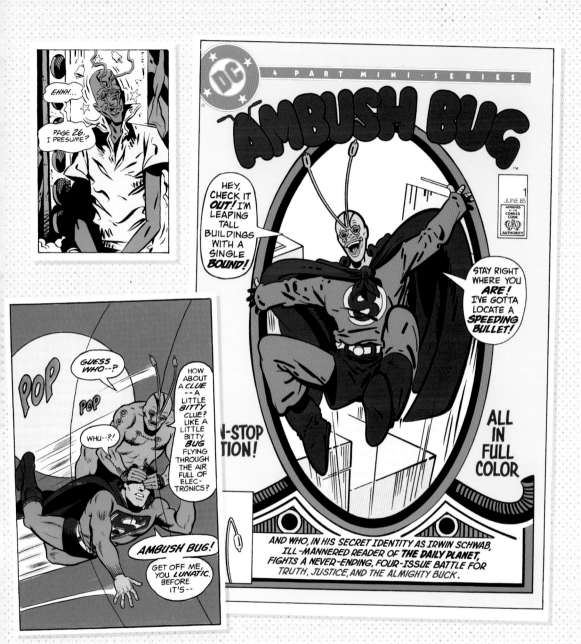

# BUG-EYED BANDIT

FIRST APPEARANCE: *THE ATOM #26 (AUGUST 1966)*

**I**T TAKES GUTS TO FLAUNT A PERIWINKLE SUIT WITH BIG YELLOW reflective bug eyes, but if you're going to call yourself the Bug-Eyed Bandit, you might as well fully commit. Bertram Larvan was a thief and inventor who used mechanical bugs to commit crimes in Ivy Town, leading to conflict with The Atom.

As an inventor, Bertram designed a mechanical insect for pest control, but unfortunately, he had no financial backing, so he stole the money he needed. Armed with his mechanical bugs, Bertram continued his crime spree as the Bug-Eyed Bandit. Early in his new career, he lucked out in learning The Atom's secret identity. That's as good as things got for the Bug-Eyed Bandit. When he tried to use an amnesiac gas on The Atom, he accidently sprayed himself and woke up in prison with no memory at all.

While locked up, Bertram was a model prisoner until he regained his memories. He broke out of jail, hell bent on revenge against The Atom. Despite capturing the hero, the Bug-Eyed Bandit suffered an electrical shock that erased his memories again.

Bertram's son took up the Bug-Eyed mantle for a time, but you couldn't keep a bug down for good. Bertram returned with an upgraded suit, taking his talents to Central City to annoy The Flash.

*STRANGE AND UNSUNG ALL-STARS OF THE DC MULTIVERSE*

# B'WANA BEAST

FIRST APPEARANCE: SHOWCASE #66 (FEBRUARY 1967)

**M**ICHAEL PAYSON "MIKE" MAXWELL DIDN'T always run around in a loin cloth yelling at the top of his lungs. After a plane crash on Mount Kilimanjaro, he took refuge in a cave, where he drank rainwater filtered through the mountain's minerals. He soon noticed the rainwater made him stronger and more agile, which helped him defeat a powerful gorilla living in the cave. In response, the gorilla, named Djuba led Mike to a magic helmet, which gave him the ability to control and communicate with animals, as well as merge them into superpowered creatures.

Mike took it upon himself to fight evil in the wilds of Tanzania as the B'wana Beast, with Djuba as his companion. Eventually he would pass the magical helmet to an African man named Dominic Mndawe, who as Freedom Beast represented South Africa in the Global Guardians.

Mike Maxwell returned as B'wana Beast years later, now considered an avatar for the Red, the force that connects all animal life in the universe. Though his loin cloth wasn't enough to persuade the head of intelligence for the United Nations to place him on the Justice League International team, he found a suitable role as a presenter during the Wild Games, a competition to determine which animal species will rule the Earth.

## DJUBA

FIRST APPEARANCE: SHOWCASE #66 (FEBRUARY 1967)

THIS MYSTICAL RED GORILLA NOT ONLY GUARDED THE POTION THAT GAVE B'WANA BEAST HIS POWERS BUT ALSO COULD HOLD HIS OWN IN A FIGHT AND READILY CAME TO B'WANA BEAST'S RESCUE WHEN NEEDED.

*LEANING INTO THE ANIMAL KINGDOM*

# DEX-STARR

FIRST APPEARANCE: FINAL CRISIS: RAGE OF THE RED LANTERNS #1 (DECEMBER 2008)

**F**EW CHARACTERS HAVE an origin as tragic as the cat named Dexter. He deserved spending all nine of his lives on a loving owner's lap; instead, he became a rage-spewing member of the intergalactic Red Lantern Corps. Dexter witnessed his owner's murder and soon was chased away from the crime scene by the police. Poor Dexter nearly met his demise when two creeps threw him in a sack and tossed him into a river. The rage in Dexter's little heart acted like a beacon, drawing a Red Lantern power ring to him. The ring was his salvation and his means to exact lethal revenge on those who harmed him.

# DOGWELDER

FIRST APPEARANCE: *HITMAN* #18 (SEPTEMBER 1997)

DOGWELDER, NO! IT'S ME!! IT'S SIXPACK! WE NEED YOU!

**T**HE DOGWELDER'S REAL NAME IS UNKNOWN... probably for the better. He was a member of Section Eight, a team of wannabe Super Heroes led by the delusional Sixpack. Dogwelder kept his identity as hidden as his face, which went unseen behind a welding mask—and rightfully so, given what he did. True to his name, he welded dead dogs to criminals' faces. Thanks to his alleyway trapping skills, he had a nearly endless supply at the ready. Dogwelder met his fate, perhaps not soon enough, when he was killed by a demon's acidic vomit during a mission with Section Eight.

You would think that would mercifully be the end of the Dogwelder's legacy, but then a happily married businessman acquired his original equipment and began welding dogs to people, including his children. After his wife divorced him, he joined Section Eight in his predecessor's place. He would come to discover that his welding powers derived from a curse by the god Anubis.

Section Eight soon learned the stars Sirius A and B were expanding and would destroy the Earth once they touched, and Dogwelder finally understood his fate. He was meant to weld the stars together, as Sirius was the dog star, after all. So, Dogwelder and his teammates knocked out some astronauts, stole their suits, and hijacked their spaceship. Dogwelder welded the two stars together, dying in the process. He saved Earth, but no one would ever know about his tremendous sacrifice.

PLEASE!

*LEANING INTO THE ANIMAL KINGDOM*

# G'NORT

FIRST APPEARANCE: *JUSTICE LEAGUE INTERNATIONAL* #10 (FEBRUARY 1988)

**G**'NORT BECAME AN official member of the Green Lantern Corps in part of a cruel plot carried out by the Poglachians, who were posing as the Guardians of the Universe while the real Guardians were with the Zamarons. Their goal was to discredit the Green Lantern Corps by giving power rings to incompetent beings. The Poglachians wanted to cause chaos for the entertainment of it all, and as a result both G'nort along with his uncle G'newmann received rings.

Guy Gardner was the one to uncover the whole thing, and against all logic he still nominated G'nort for a genuine membership with the Green Lantern Corps. With his newfound title and confidence, G'nort would go on to pester the Justice League to let him join.

Early in G'nort's career as a Green Lantern, he inadvertently got mixed up with the Justice League's battle with the Manhunters, who quickly recognized his incompetence and realized the Green Lantern Corps had assigned him to patrol an uninhabited sector of space to keep him out of trouble. Using this knowledge to their advantage, the Manhunters set up their home planet in G'nort's sector. When Hal Jordan, Superman, and the rest of the Justice League members showed up, G'nort joined them. Comically, his only contribution to the fight was getting stuck in the ventilation system.

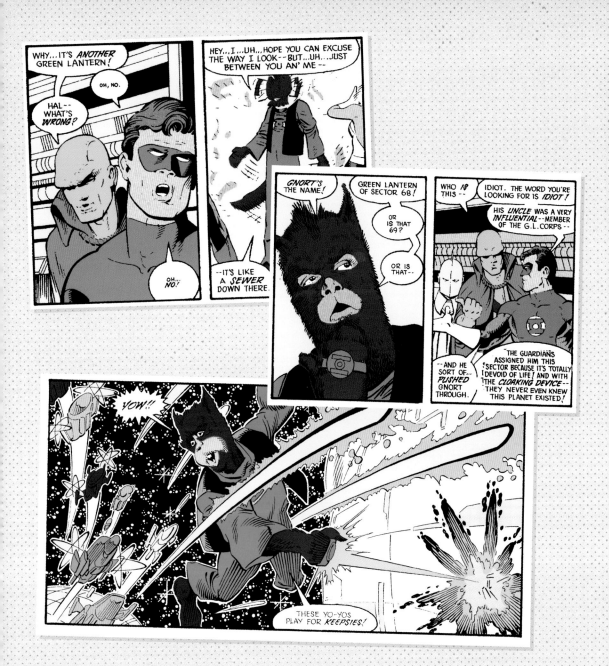

# INSECT QUEEN

FIRST APPEARANCE: SUPERMAN #671 (FEBRUARY 2008)

**S**UPERMAN'S CHILDHOOD FRIEND LANA LANG ONCE RECEIVED a biogenic ring that gave her insect-like powers, which she used occasionally as a child. But her buzzworthy alter ego was later adopted by a sexy insectoid, born among the alien All-Hive race, who was sent to Earth to start a new colony. On Earth, this Insect Queen quickly became an ally of Lex Luthor. He promised her his assistance with taking over the Earth, while she supplied him with drones to help him find Kryptonite. She also transformed workers on Luthor's moon base into insectoid beings.

Insect Queen took things a step further when she abducted Lana Lang and used her genetic template to assume her form but with insectoid features. She wasn't in this new form all that long before Superman trapped her, while saving Lana.

BUT AGAIN, LANA IS ON THE JOB... AS A **DRAGONFLY GIRL!**

I SAW THE WHOLE THING! IF I COULD ONLY SHAKE OUT THE **GREEN K** DUST... BUT IN THIS FORM, I CAN'T DO IT! HMM... THERE MUST BE SOME INSECT SHAPE I CAN TAKE ON TO HANDLE THIS JOB!

Insect Queen was later revealed to have implanted some of her own DNA in Lana, which in time caused Lana to fall ill and become enveloped in a cocoon. From that cocoon sprang forth a reborn Insect Queen set on using Kryptonian genetics to create an army of hybrid super-ants. Fortunately, Supergirl freed Lana from this insectoid possession. It remains to be seen when Insect Queen may start buzzing around again.

# LORI LEMARIS

FIRST APPEARANCE: SUPERMAN #129 (MAY 1959)

LORI LEMARIS HAILED FROM THE ATLANTEAN city of Tritonis, whose citizens developed fish-like tails. An early love of the young Clark Kent, Lori showed him what romance looked like under the sea.

Lori and Clark first met as kids. At the time, she had a bad habit of telling lies, including attempting to trick Superboy into believing she was two thousand years old. In turn, Superboy tricked her into an experiment that helped her learn to stop lying. The pair were then both hypnotized by Lori's father into forgetting each other, as he wished to keep their undersea kingdom hidden. But Lori couldn't resist the lure of the surface world, where she got around in a wheelchair and slept in saltwater baths at night. She and Clark—early in his career as Superman—met once more as classmates at Metropolis University. They quickly fell in love, and Clark proposed, though Lori said no, not ready to reveal her secret. But when a dam burst and a dangerous flood ensued, Lori leapt into action, aiding Superman in his rescue efforts. With all their secrets laid bare, the pair concluded they had too many differences to ever be together and parted with a kiss.

Superman would go on to inadvertently introduce Lori to her husband, Ronal, when he sought the alien merman's help when Lori was severely injured by a fisherman. In turn, Lori became a regular ally to Superman, as well as his cousin Supergirl, with adventures bringing her all the way into the thirtieth century. From their most peculiar introduction, Lori and Superman were fated to come to each other's rescue, a relationship unlike any other Superman maintained.

# MANHAWKS

FIRST APPEARANCE: *THE BRAVE AND THE BOLD* #43 (SEPTEMBER 1962)

**T**HE MANHAWKS WERE THE FAR LESS ATTRACTIVE VERSION OF the Thanagarians. They were large telepathic hawk-like aliens with human-level intelligence. The Manhawks were nomadic interplanetary thieves and traveled throughout space at near warp speed to appease their klepto-fueled desires. As though their appearance couldn't get any more nightmarish, when the Manhawks robbed a world, they wore masks resembling the inhabitants of the planets. The eye slits of their masks were equipped with highly destructive energy rays that could transport objects to another dimension, the secret to their effective thievery. Their energy beams could also be used to knock people unconscious.

The Manhawks were the sole reason the Thanagarians developed a police force. After they robbed the planet of Thanagar, its inhabitants started committing similar crimes, which compelled the Thanagarians to stop them.

*STRANGE AND UNSUNG ALL-STARS OF THE DC MULTIVERSE*

# REX THE WONDER DOG

FIRST APPEARANCE: *THE ADVENTURES OF REX THE WONDER DOG* #1 (JANUARY/FEBRUARY 1952)

**R**EX THE WONDER DOG WAS NO SLOUCH in the Super Hero department. During World War II, he was used as a test subject in a supersoldier program, in which he was injected with a formula that gave him human-level intelligence. Rex was immediately put to work in the US Army K-9 Corps, where he served after World War II ended and into the Korean War.

Returning to the United States after the wars, Rex was taken in by the Dennis family, helping clear Phillip Dennis of murder charges before traveling the world with Phillip's brother Danny. His fulfilling postwar life entailed being a Hollywood stunt dog as well as a park ranger. But Rex started to grow old, and his time in the spotlight was nearly done. That is, until he and Bobo (the Detective Chimp) inadvertently drank from the Fountain of Youth. The pair drank, and their vitality was restored. The fountain gave Rex the power to speak and put him in possession of the knowledge of "force mind," which gave him some of the same enhanced mental abilities as Gorilla Grodd.

LEANING INTO THE ANIMAL KINGDOM

**D**RAWING ON INSPIRATION FROM THE LEGION OF SUPER-Heroes, the Space Canine Patrol Agents were an adorable team from the Silver Age. The group of canine characters lived in a fully anthropomorphic civilization. The pups also had their own language, which was fortunately translated for readers.

The Space Canine Patrol Agents were often accompanied by Superboy's pet Krypto on missions protecting the universe. In their first appearance they battled the Canine Caper Gang, and Krypto went under the guise of Air Dale, the flying dog. Each member of the canine team had a special gift: one of Tusky Husky's teeth grew to the size of a tusk, Mammoth Miss could inflate herself, Chameleon Collie could transform herself into any kind of animal, Hot Dog had heat powers, Prophetic Pup had precognitive powers, Paw Pooch could grow an extra limb, and Tail Terrier could elongate his tail into a whip or lasso. And, of course, their headquarters was shaped like a doghouse. The Space Canine Patrol Agents' battle cry whenever they were all together was "Big dog, big dog, bow wow wow! We'll fight evil, now, now, now!" and their symbol, rightfully, was the constellation Canis Major, otherwise known as Big Dog.

The crew hasn't been seen in comics in ages, other than when Animal Man found them fighting over food scraps in the realm of Limbo.

# SPACE CAT PATROL AGENTS

FIRST APPEARANCE: *SUPERBOY* #131 (JULY 1966)

THE SPACE CAT PATROL AGENTS WERE THE FELINE COUNTERPARTS TO THE SPACE CANINE PATROL AGENTS, OPERATING ON ANOTHER PLANET. THE TEAM WAS ALSO MADE UP OF MEMBERS WITH UNIQUE SPECIAL POWERS: CRAB-TABBY HAD CRAB-LIKE CLAWS, ATOMIC TOM POSSESSED NUCLEAR POWERS, AND POWER PUSS COULD FIRE LIGHTNING BOLTS FROM ITS EYES. DESPITE MAKING JUST ONE APPEARANCE, THEY MADE AN INDELIBLE IMPRESSION.

*LEANING INTO THE ANIMAL KINGDOM*

# TAWKY TAWNY

FIRST APPEARANCE: *CAPTAIN MARVEL ADVENTURES* #79 (DECEMBER 1947)

**I**N TAWKY TAWNY'S ORIGINAL INCARNATION, HE STARTED LIFE as an ordinary tiger cub in the jungles of South Asia. Tragically, a big game hunter killed his mother. That heinous act led to him being found by a young American boy named Tommy Todd, who gave him the name Mr. Tawny. The two ran away after Mr. Tawny was accused of killing villagers, when—in truth—another tiger was at fault. While in the jungle, Tommy wished Mr. Tawny had the ability to talk. Along came a hermit with a bowl of magical liquid that made the wish come true. Years later, Mr. Tawny traveled to the United States and helped Todd out after he was framed for murder. With the aid of Shazam!, Mr. Tawny tracked down the real killer and exonerated his friend.

The zoot suit–wearing tiger had a different origin once Shazam! was integrated into the DC Multiverse after the *Crisis on Infinite Earths*. He started off as a stuffed tiger doll brought to life by Lord Satanus to help the Shazam! family fight against his sister Blaze. Tawky appeared as a living being dressed in suit coat and slacks only to Billy, Mary, and Dudley. Eventually, he was made fully real through the magic of Ibis the Invincible.

Tawky played a pivotal role in helping Freddy Freeman during his trials to secure the power of Shazam! Tawky had information on the location of Mercury that he refused to tell Sabrina, Freddy's rival, when she found him first. Sabrina tried to threaten Tawky, but she quickly learned the former plushie was no softie: he transformed into a saber-toothed tiger and attacked her. Later, Tawky held his own once again against Darkseid's son Kalibak, defeating him in combat and gaining the admiration of Kalibak's tiger-soldiers in the process.

Most recently, Tawky returned as a resident of the Wildlands, one of the Seven Magic Lands. Despite the Wildlands being home to anthropomorphic animals, tigers were still regarded as wild and ostracized from society. Tawky's penchant for fashion and the arts led to his arrest, until he fled the Wildlands with the Shazam! family.

LEANING INTO THE ANIMAL KINGDOM

# TOPO

FIRST APPEARANCE: ADVENTURE COMICS #229 (OCTOBER 1956)

**T**OPO THE OCTOPUS WAS ONE OF THE most notable animal sidekicks in comics, and rightfully so. You can't go wrong with having an octopus for the gig: they're exceptionally smart, they're excellent escape artists, and Topo was even an accomplished musician.

Topo was born near the underwater city of Atlantis and became Aquaman's beloved pet, sidekick, childcare provider, and occasional lie detector. In several of his early appearances, Aquaman could be seen riding Topo like an eight-limbed organic jet ski. They spent a lot of time assisting sailors at sea, helping with everything from ship maintenance to salvaging sunken vessels.

When Topo wasn't working with Aquaman, he helped other Super Heroes from time to time. It's rumored Green Arrow taught him archery. He demonstrated some telepathic abilities talking to other sea creatures and could even receive thoughts from people.

In his latest incarnation, Topo appeared as a colossal and ancient guardian of Atlantis who answered only to the king, Aquaman.

LEANING INTO THE ANIMAL KINGDOM

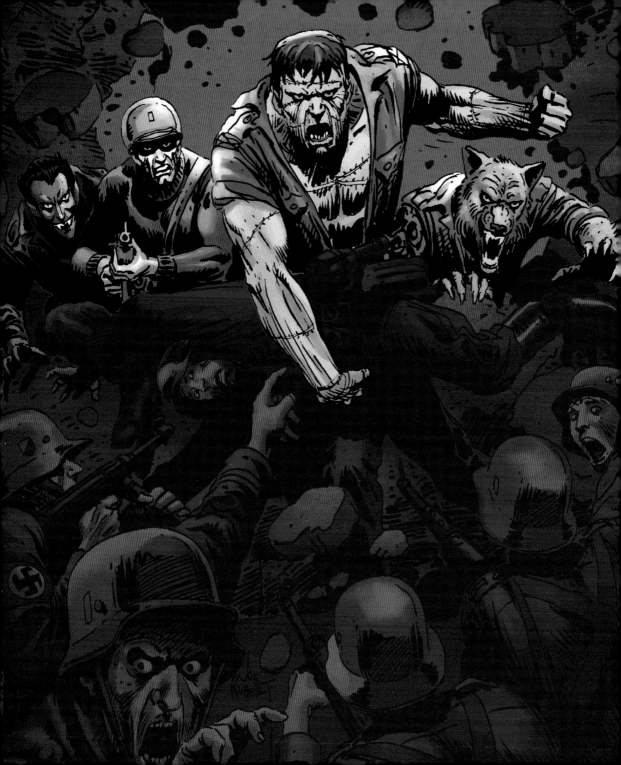

# THE CREATURE COMMANDOS

FIRST APPEARANCE: WEIRD WAR TALES #93 (NOVEMBER 1980)

ANYONE WHO LOOKS FORWARD TO HALLOWEEN WILL APPRECIATE SOME OF THE CREATIONS FROM THE GOOD FOLKS AT PROJECT M. THEY'VE HAD YOUR GHASTLY INTERESTS COVERED SINCE WORLD WAR II. THEIR MOST PROMINENT SCIENTIST, PROFESSOR MAZURSKY, TOOK ADVANTAGE OF THE DELICATE HUMAN PSYCHE BY CREATING A TEAM OF SUPERPOWERED SOLDIERS WHOSE APPEARANCE WOULD STRIKE FEAR INTO ENEMY FORCES.

**M**AZURSKY RECRUITED SOLDIERS WARREN GRIFFITH, Vincent Velcoro, and Elliot Taylor for the experiment. The ambitious scientist transformed them into monstrous warriors, with Griffith becoming the werewolf Wolfpack, Velcoro now a vampire, and Taylor turning into the Frankenstein-like Patchwork. The trio were soon joined by a fourth, Dr. Myrra Rhodes, who was made into the snake-haired Medusa. The fear-inducing crew were led in the field by a human, Lieutenant Matthew Shrieve. They worked out of a base in London, near their first two missions in France.

The Creature Commandos weren't moral boy scouts. They were created to get the job done and, for some of them, give whatever was required to see the mission to completion. However, their actions haunted them just as their appearances haunted those who encountered them out on the battlefield.

Soon enough, through their early successes, the Creature Commandos were given broader assignments that spanned the globe. During this time, they were sent to the mythical Dinosaur Island in the South Pacific, where they met the G.I. Robot J.A.K.E. After he sacrificed himself saving some American sailors, his successor, J.A.K.E. II, joined the Creature Commandos as their fifth member.

The team was court-martialed and sentenced to death via firing squad for the charge of "rebelliously displaying signs of humanity," but at the last minute, their sentence was commuted so they could perform another mission. They were tasked with operating a rocket targeting Hitler. Ever the recipients of bad luck, the Creature Commandos' rocket veered off course into space, where they were eventually found by the villain Brainiac and placed in suspended animation. Over the years, the government instituted other versions of the team, but the originals were later discovered and freed by Superman and returned to the US government for duty.

Following the events of *Flashpoint*, the Creature Commandos were reintroduced as byproducts of the Super-Human Advanced Defense Executive (S.H.A.D.E.), a counterterrorism group led by the immortal Father Time. The

main team was created by Professor Mazursky's daughter, Nina Mazursky, who had an amphibian-like appearance. This iteration included past members Vincent Velcoro and Warren Griffith, along with the mummy Khalis, and they were led by the original Frankenstein (sorry, no Patchwork in this reality).

No matter the iteration, the Creature Commandos were great characters for introspective storytelling. The way they navigated the world around them often served as commentary on judging people for their physical appearance alone rather than the content of their character.

# MATTHEW SHRIEVE

*LIEUTENANT MATTHEW SHRIEVE* was an army intelligence officer who was the only human member and leader of the first incarnation of the Creature Commandos. Lt. Shrieve may have been human, but the way he treated his troops was quite monstrous because he couldn't stand them. None of their outward appearances could ever be uglier than his heart and his conduct.

# MEDUSA

**DR. MYRRA RHODES** was perhaps the most interesting member of the Creature Commandos. Ironically, she was a plastic surgeon before she was transformed into a modern-day Medusa.

Alone among humans, particularly Lt. Shrieve, Dr. Rhodes was empathetic toward the Creature Commandos. While she still had her "normal" appearance, she advocated for them and reminded them they were still human despite their looks. Her accident happened on the fateful day she performed surgery on Lt. Shrieve, fixing his face, which had been damaged in battle. When he woke after surgery, he berated the members of his squad, as he often did. Dr. Rhodes went after the Commandos after they fled Lt. Shrieve's recovery room. In their hasty exit, they knocked over experimental chemicals; exposed to the mixture, Dr. Rhodes found her hair transformed into a head full of snakes.

Dr. Rhodes joined the Creature Commandos because she was no longer able to practice medicine—no one would seek out plastic surgery consultations from someone who looked like a monster straight out of Greek mythology. Given how kind she had been to members of the Creature Commandos, the team welcomed her with open arms.

In her adventures with the Creature Commandos, Dr. Rhodes was often the voice of reason, and empathy was, perhaps, her greatest power. Once while on a mission in Sicily she convinced Inferna, the Greek goddess of flame, not to burn Lt. Shrieve alive. Dr. Rhodes sympathized with the goddess, who couldn't touch anyone or anything without burning them, and appealed to her humanity by saying, "Without a heart, you could not weep."

# PATCHWORK

**ELLIOT TAYLOR** was a good-hearted, kind soul others called Lucky. While stationed in the Pacific Ocean during World War II, he stepped on a land mine, but he got a second chance at life thanks to Project M. Once Taylor was pieced back together, he was a Frankenstein's monster in every way imaginable. But the mute giant wasn't built for the dirty work the team needed: grief from a mission drove him to attempt suicide. Lucky might've been an assemblage of broken parts, but his heart always remained intact.

# VINCENT VELCORO

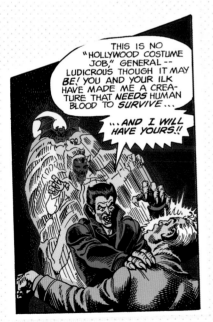

**VINCENT VELCORO** was a US soldier facing a thirty-year sentence for treason. He was offered the opportunity to avoid spending half his life behind bars by volunteering for Project M. Little did he know it wasn't necessarily a better alternative. Vincent was turned into a scientific vampire through injections of a compound of experimental chemicals and blood extracted from the New Mexican vampire bat.

He had all the physical characteristics associated with vampires and their bloodlust, as well as the ability to change into a human-sized bat. Unfortunately, what he didn't inherit was their suave demeanor because he often scared those he encountered.

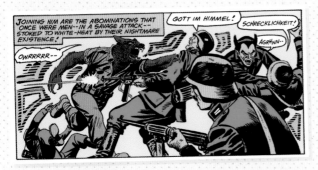

# WOLFPACK

**PVT. WARREN GRIFFITH** came to Project M with his own baggage. The Oklahoma native was diagnosed with lycanthropy, a form of insanity in which he imagined himself a wolf. The Project M scientists took advantage of this condition to allow him to physically transform into a snarling werewolf. Since Griffith was an artificial werewolf, his transformations were independent of the phases of the moon. It took a great deal of effort for him to learn how to control himself when he transformed.

# NINA MAZURSKY

*NINA MAZURSKY* experimented on herself instead of others, unlike her father. As a result, she had a monstrous outward appearance.

Nina dedicated her life to working with S.H.A.D.E. after her daughter died and her husband deserted her. Her first attempt to create the Creature Commandos, which she grew from birth, resulted in psychopathic monsters unable to cope with their urges and desires. As a result, she decided to use fully formed humans who could emotionally handle their transformations. She wasn't going to let them go through it alone, so she experimented on herself as well, as to not subject them to anything she wouldn't go through herself.

# FRANKENSTEIN

***THE MAN. THE MYTH. THE MODERN PROMETHEUS.*** Assembled by Dr. Victor Frankenstein using stolen body parts and blood of the evil, time-traveling Mr. Melmoth, this classic monster has lived for a century and fought many wars. He found love with the multi-armed and high-haired Bride, with whom he fathered a son. Though now divorced, he still worked with the Bride at S.H.A.D.E. Frankenstein's adventures also led him to join the Seven Soldiers, Justice League Dark, and his own assembly of heroes he deemed "most monstrous."

*THE CREATURE COMMANDOS*

# KHALIS

**KHALIS** was a revived mummy and the designated medic for Nina's team. To go along with his superhuman strength and durability, he also had the power to heal others with the bandages from his body. As gross as that sounds, it was vital for a team constantly in harm's way.

When he wasn't busy healing others, Khalis could use his staff to channel a blast of energy strong enough to turn anyone within its radius into nothing more than a forgotten memory.

# G.I. ROBOT II & III

FIRST APPEARANCE: *WEIRD WAR TALES* #101 (JULY 1981)

DURING WORLD WAR II, SCIENTIFIC ADVANCEMENTS LED TO THE
CREATION OF MULTIPLE G.I. ROBOTS, MOST NOTABLY THE MODELS
KNOWN AS J.A.K.E. I AND J.A.K.E. II (WHICH AT DIFFERENT TIMES
STOOD FOR JOINT ACTION KILLING ENGINE, JOINT ALLIED KILLER
ELITE, AND JUNGLE AUTOMATIC KILLER EXPERIMENTAL).

US SCIENTISTS HOPED THESE ROBOTS WOULD REPLACE LIVE
SOLDIERS ON THE BATTLEFIELD TO REDUCE THE NUMBER OF HUMAN
CASUALTIES. J.A.K.E. I WAS A ROBOT DESIGNED TO BE DEVOID
OF EMOTIONS AND TO TAKE BASIC COMMANDS. LIKE MANY OTHER
CHARACTERS FROM SILVER AGE WAR STORIES, HE
WAS PART OF AN ASSORTMENT OF NON SEQUITUR
ADVENTURES, MANY OF WHICH TOOK PLACE
ON DINOSAUR ISLAND. IN ONE OF HIS MAJOR
STORY ARCS, G.I. ROBOT SHOWED SIGNS OF
INDEPENDENCE. HE PUSHED A FELLOW SOLDIER
TO SAFETY DURING A FIGHT WITH AN ENEMY ROBOT.
J.A.K.E. II, CREATED AFTER HIS PREDECESSOR
WAS DESTROYED, SERVED AS AN UNOFFICIAL
MEMBER OF THE CREATURE COMMANDOS.

NEW VERSIONS OF G.I. ROBOT HAVE SHOWN
UP UNEXPECTEDLY SINCE HIS WARTIME DEBUT,
MOST RECENTLY IN ONE-STAR SQUADRON, AN
ON-DEMAND SUPER HERO TEAM LED BY RED
TORNADO, WHO TAKE SERVICE REQUESTS FOR
THEIR HEROICS THROUGH AN APP.

THE CREATURE COMMANDOS

# GROUP PROJECTS

**E**VERYONE BRINGS SOMETHING UNIQUE TO THEIR GROUP. YOU HAVE YOUR OVERACHIEVERS, YOUR SLACKERS, YOUR RESEARCH EXPERTS, YOUR ORGANIZERS, AND THEN THOSE WHO FALL SOMEWHERE IN THE MIDDLE. ALL THE MOVING PIECES CAN MAKE BEING PART OF A GROUP UTTERLY EXHAUSTING. FOR THE GROUPS IN THIS SECTION, THE EXPERIENCE IS GOING TO BE CHAOTIC—THANKFULLY ALL YOU HAVE TO DO IS GO ALONG FOR THE RIDE.

# THE BAD AND BEAUTIFUL BABES OF WRESTLING

FIRST APPEARANCE: MISTER MIRACLE #24 (FEBRUARY 1991)

**T**HE BAD AND BEAUTIFUL BABES OF Wrestling were an all-woman wrestling group based out of New York City. While looking for a new job, Big Barda tried out for the team and quickly beat the reigning champion. She was hired right away. But no one told her the wrestling moves weren't meant to be real. In her short time as a member of the wrestling group, she met Mama Mound, Amazon Angel, Pulsating Pythona, Mini-Maxine, Betty Bodyslam, Roweena, Pete the promoter, and Big Lou the owner.

# BULLETMAN AND BULLETGIRL

FIRST APPEARANCE: NICKEL COMICS #1 (MAY 1940)

**J**IM BARR WAS THE SON OF A POLICE OFFICER WHO WAS murdered in the line of duty. Unlike Bruce Wayne, Jim didn't have access to a substantial amount of wealth and advanced tech for his revenge. He tried to follow in his father's footsteps but was rejected by the police academy because he didn't meet their physical standards. He ended up applying for a job in ballistics instead.

Jim used chemistry to develop a serum to pump up his muscle mass and intelligence. With his increased IQ, Jim invented a gravity regulator helmet, a variation of Hawkman's Nth Metal. The helmet gave him the ability to fly and deflect bullets. He created another one for his wife, Susan Kent. The purpose of the helmet's bullet shape was pretty straightforward; they could pierce larger objects—like a tank.

Their legacy was continued by research scientist Lance Harrower, who developed a thin metal skin that could bond with collagen and make tissue indestructible. However, when he tested the Smartskin, it suffocated him. Also exposed to it, Alix narrowly survived. As the Bulleteer, Alix went on to live out her husband's dream of becoming a Super Hero, but on her own terms.

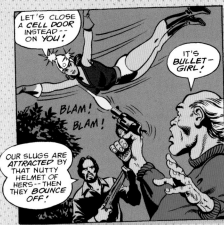

GROUP PROJECTS

# THE CADRE

FIRST APPEARANCE: JUSTICE LEAGUE OF AMERICA #235 (FEBRUARY 1985)

**T**HE CADRE WAS A GROUP OF VILLAINS ASSEMBLED BY AN ALIEN known as the Overmaster. He was an omnipotent entity that acted like a heavenly judge. When he deemed a world unworthy, he collected specimens of its inhabitants and destroyed the rest. He came to Earth to test humanity by creating the Cadre. The Overmaster gave superpowers to individuals with the singular goal of pitting them against the Justice League of America in a contest to determine the future of the planet.

**BLACK MASS** Physicist Geoffrey Thibodeaux wasn't physically imposing until he was bulked up by the Overmaster and given special bracelets that conferred powers of gravity. Under the alias Black Mass, he joined the Cadre. Eventually the bracelets and their power bonded with his body permanently.

**CROWBAR** Malcolm Tandy was the leader of his own gang before he was recruited by the Overmaster to be the first member of the Cadre. He was imbued with powers that turned his weapon of choice, a crowbar, into an instrument of destructive force.

**FASTBALL** John Malone was a former minor league baseball player who made it to the Super-Villain major leagues thanks to the Overmaster. He outfitted John with a powerful exoskeleton that allowed him to throw explosive spheres.

**NIGHTFALL** Before she became a member of the Cadre, Nightfall was among the large number of female Super-Villains brought together by the ancient sorceress Circe to attack New York City.

 **SHATTERFIST I & II** The first Shatterfist was a Korean martial arts master given the power to disintegrate things with his touch. He served as a member and field commander of the Cadre until he was killed by the Super Hero Ice. The next Shatterfist had a similar background and powerset but was American. In addition to the Cadre, he was a member of the Secret Society of Super-Villains.

 **SHRIKE** Vanessa Kingsbury was introduced as a mental health patient on a lifelong spiritual quest. When she escaped the asylum where she was held, she encountered the Overmaster. He turned her into an orange-skinned, prehensile-tailed, winged metahuman and one of the original Cadre members.

Although Shrike was a formidable individual, she suffered from poor mental health, which left her vulnerable. She was taken advantage of by those who desired to use her powers for their own plans. At one point, she lost her wings and tail, which drove her to embark on a journey into Christianity. This traumatic path eventually led her to a predatory reverend named Flint Yuma. Shrike ultimately killed Yuma with one of her powers—a scream strong enough to mortally wound someone.

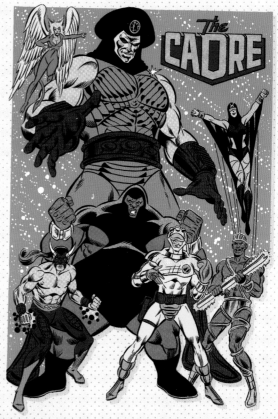

# THE DEMOLITION TEAM

FIRST APPEARANCE: GREEN LANTERN #176 (MAY 1984)

**T**HE DEMOLITION TEAM WAS MADE UP OF HIGHLY SKILLED mercenaries outfitted with special power-tool-inspired weapons that could both destroy and rebuild an apartment complex. They picked their assignments based on how many zeroes were on the check. Their first mission came by way of Congressman Jason Bloch, who hired them to destroy the Los Angeles branch of Ferris Aircraft. Bloch wanted to fulfill a promise to his late father and get revenge against an old enemy, Carl Ferris, its owner. Bloch was worried about Green Lantern battling the Demolition Team and tracing the plan back to him, but the team ended up battling the villain known as Predator instead. He wrecked the team and left Ferris Aircraft a flaming mess.

After their initial defeat, the Demolition Team had some success in their subsequent appearances, but the team suffered major losses due to the OMACs—human bodies transformed by a virus into cyborgs that assassinate all beings with superpowers. Hardhat was the only member of the Demolition Team to survive the events of *The OMAC Project* miniseries.

 **HARDHAT** was a New York boxer outfitted with a power-pack helmet and harness that turned him into a juggernaut.

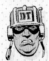 **JACKHAMMER** hailed from Houston, Texas, where he worked as an oil rig wildcatter. While a member of the Demolition Team, he operated a high-tech jackhammer, hence the name.

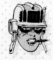 **ROSIE** was a no-nonsense former bar owner from New Orleans, which made her the perfect team leader. She used a gun that fired red-hot rivets.

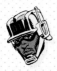 **SCOOPSHOVEL** was a San Diego, California, native and a jai alai player. As a member of the Demolition Team, he used an advanced hydraulic power arm that could dig up almost anything.

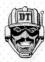 **STEAMROLLER** was originally from Chicago, Illinois, where he was a stunt cyclist before he got his tricked-out steamroller.

*GROUP PROJECTS*

# THE FORCE OF JULY

FIRST APPEARANCE: *BATMAN AND THE OUTSIDERS* ANNUAL #1 (SEPTEMBER 1984)

**T**HIS GROUP OF OUTSIDER VILLAINS OPERATED UNDER the personal supervision of the American Security Agency's director, B. Eric Blairman. Because the ASA's mission was to eliminate subversive activities contrary to the interests of the United States—the Force of July found themselves up against the Outsiders more than once.

Unbeknownst to the Force of July, Blairman took advantage of their patriotism to further his own agenda, known as Project Orwell, which entailed building a satellite to spy on people through their televisions. These overeager political beavers helped Blairman acquire the materials needed to make Project Orwell a reality.

Most of the team died as a result of run-ins with the Suicide Squad. But flag-waving patriotism never goes out of fashion.

**LADY LIBERTY** Looking like she stepped off Ellis Island, Lady Liberty fired energy blasts from her torch.

**MAJOR VICTORY** Major Victory, the team's leader, displayed great strength and endurance.

**MAYFLOWER** The young Mayflower possessed the elemental ability to control plant life.

**SILENT MAJORITY** could duplicate himself into multiple bodies.

**SPARKLER** Though just a boy, Sparkler had enough firepower to light up any Fourth of July celebration.

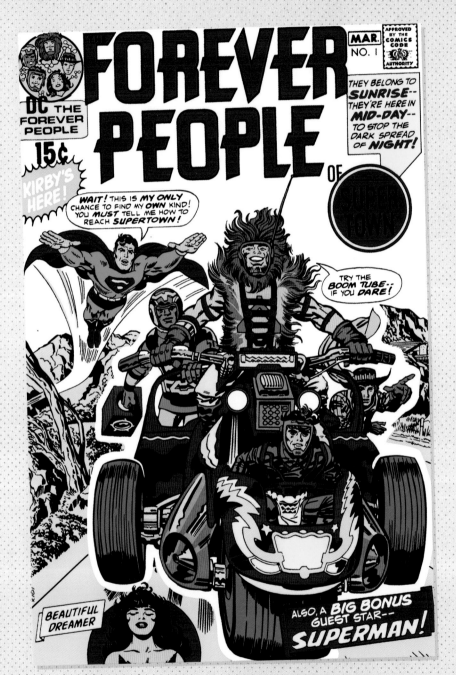

STRANGE AND UNSUNG ALL-STARS OF THE DC MULTIVERSE

# THE FOREVER PEOPLE

FIRST APPEARANCE: FOREVER PEOPLE #1 (FEBRUARY/MARCH 1971)

**T**HE FOREVER PEOPLE STARTED OFF AS A SOCIAL EXPERIMENT for Highfather, also known as Izaya—a warrior from the patriarchal planet of New Genesis and father of Scott Free. Izaya selected five human children, each from a different period of Earth's history—Beautiful Dreamer, Big Bear, Moonrider, Serifan, and Vykin. He chose them because they were fated to have brief and painful existences. Once on New Genesis, the children were raised as New Gods.

The New Gods soon found themselves targets of the Highfather's evil counterpart, the lord of Apokolips, Darkseid. He kidnapped Beautiful Dreamer, but with the help of Superman, the group freed her using their sentient device known as a Mother Box to summon the powerful Infinity Man. They all decided to remain on Earth a bit longer to explore the world and discover a part of their missing heritage. However, Darkseid was never too far away and continued to give the group grief.

The Forever People couldn't evade Darkseid forever. He sent one of his agents, Devilance the Pursuer, to track and kill the group. The ensuing battle with Infinity Man destroyed both opponents and stranded the Forever People on the planet Adon. Beautiful Dreamer and Big Bear fell in love, married, and soon were expecting a child. Moonrider and Vykin focused their efforts on cultivating the world's civilian population. With the power of the Mother Box, the pair managed to create the community Forevertown, but the Mother Box overloaded, killing Vykin. Moonrider continued their work, becoming mayor of the community. He even fell in love and married one of the locals, a woman named Mina.

The good times wouldn't last. Thanks to the corruptive entity known as the Dark, time on Adon was reversed, which de-aged the Forever People. Dreamer was no longer pregnant, Moonrider never married Mina, Vykin never carried

out the experiment that killed him, and the planet's natives never advanced. Everything they had experienced was erased, and the group went back to Earth with the help of Maya, the spirit of the Mother Box. Maya resurrected Infinity Man, who defeated the Dark. As for Maya, in her final sacrifice, she transferred her spirit inside Beautiful Dreamer's womb, allowing her and Big Bear to have the daughter they had lost.

 **BEAUTIFUL DREAMER** In addition to her illusion-casting powers, Beautiful Dreamer was known to be one of the few people in existence whose mind could comprehend the all-powerful anti-life equation, the formula that could be used to dominate the will of all sentient beings.

 **BIG BEAR** The eldest of the Forever People, the mammoth Big Bear possessed greater strength than most on New Genesis and could control the density of objects. He also piloted the Super-Cycle, the group's primary means of transportation.

 **MOONRIDER** Mark Moonrider's megaton touch projected bolts of destructive energy from his hands. He served as the Forever People's leader.

 **SERIFAN** With a Western style, Serifan was known as a "sensitive," possessing limited telepathic abilities. In the band of his cowboy hat, he carried "cosmic cartridges," which had an array of functions including generating force fields and antigravity.

 **SERIFANA** Following the events of *Flashpoint*, a new incarnation of the Forever People was introduced. Each member mirrored their previous incarnation, save for Serifana, who was now Vykin's twin sister and far more interested in the Forever People's mission.

 **VYKIN** was originally the son of a Roman Empire legionnaire. Of the bunch, Vykin was the most dedicated to Highfather. His "magna-power" allowed him to project magnetic energy, and he could mentally trace atomic patterns. He also bore the responsibility of carrying the group's Mother Box.

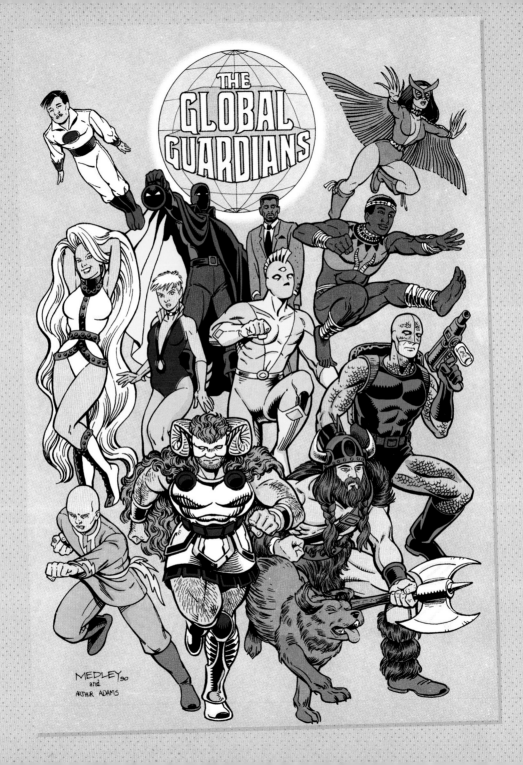

# THE GLOBAL GUARDIANS

FIRST APPEARANCE: DC COMICS PRESENTS #46 (JUNE 1982)

**T**HE WORLD NEEDED SAVING OUTSIDE OF THE UNITED STATES of America, so the Global Guardians took it upon themselves to become their own versions of Batman and Robin as international crime fighters.

The team of heroes was created during the Cold War and functioned in the same fashion as the Justice League. However, they didn't have government backing, which often limited how they could operate. Still, the Guardians did what they could to function like a support system, often teaming up with neighboring heroes unable to get immediate assistance from other organizations.

The core members who made up the Guardians at first were Icemaiden, Rising Sun, Green Flame, and Tasmanian Devil. Their first recorded meeting brought them together with Infinity Inc. to defeat the Wizard's new Injustice Unlimited team. The meeting was mostly arm wrestling between Tasmanian Devil and Nuklon before the Wizard showed up with his new team in tow. The two groups were able to squash the tension long enough to defeat Injustice Unlimited. Funnily enough, it led to the United Nations funding a new Justice League International team, which left the Guardians with nothing at all but the capes on their backs.

Without any kind of financial support, the Global Guardians eventually broke up, setting up some members to fall prey to the likes of Queen Bee of Bialya, a villain who loved to use mind-control tactics. She had an immediate use for ex-Guardians Wild Huntsman, Rising Sun, and Tuatara. Queen Bee couldn't take on Captain Atom or his Justice League Europe team on her own; under her influence ex-Guardians did the work for her. Her actions led to the destruction of the Guardians' former headquarters by the Justice League.

 **BUSHMASTER** Bernal Rojas was a world-renowned herpetologist from Caracas, Venezuela. With his expansive knowledge of reptiles, he replicated their abilities using a high-tech suit and equipment to become Bushmaster.

 **CASCADE** Sujatmi Sunowaparti came from a big family on the Indonesian island of Java. She worked under dangerous conditions in a refining factory to support her family. Caught in a battle between factions in Borneo, she was exposed to a radioactive isotope that activated her metagene, giving her the power to transform all or any part of her body into water. She could also manipulate huge bodies of water, turning them into various shapes, anything from a large sphere to a small triangle.

 **CENTRIX** Mark Armstrong was a high-powered business executive turned hippie raised in Manitoba, Canada. A late bloomer, he did not develop his superpowers until after he left college. They allowed him to create force waves in equal and opposite directions from his body. After he perfected the use of his powers, he took on the Super Hero identity of Centrix.

After becoming disillusioned with his job and feeling a growing spiritual void, he divorced his wife of three years and moved to Vancouver Island. He began studying star charts and reading tarot. He lived off his wealth while fighting crime as Centrix.

 **CHRYSALIS** was a nonhuman member of the Global Guardians, a robot originally designed and manufactured by the anti-Semitic Dr. Gerald Yves Martet in France. Chrysalis housed a swarm of genetically engineered butterflies that could mimic other insects

and carried a deadly disease. She could also fly, carry bee stingers and venom, and stick to walls.

 **CRIMSON FOX** was the Super Hero alias for one of the D'Aramis twins, Constance. Her mother died of cancer caused by experiments performed at the pharmaceutical company where she was a research scientist. Fearing they could have a lawsuit on their hands, the company also killed her father. She and her twin sister, Vivian, swore revenge against Maurice Puanteur, the CEO of the company. They established a competing company, Revson, to put him out of business.

The D'Aramis twins ensured the secrecy of their identity by faking Constance's death. This allowed Vivian to tend to matters of business while Constance battled crime as the Crimson Fox.

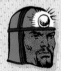 **DOCTOR MIST** Originally known as Nonmo, the immortal wizard-king of the African empire of Kor, Dr. Mist was more than eleven thousand years old. In addition to his formidable magical powers, he founded the Global Guardians.

 **FIRE** Beatriz Bonilla da Costa was one of the more popular members of the Global Guardians. Also known as the Green Flame and the Green Fury, Beatriz was born to a tribe of people known as the Ge. She was prophesied to one day have great powers as determined by the Sky Spirit. When she turned fifteen years old, the prophecy came to fruition. She soon after started her Super Hero career as the Green Flame and worked as head of the Brazilian branch of Wayne Industries as her day job.

Following *Crisis on Infinite Earths*, Beatriz was reintroduced as a supermodel from Rio de Janeiro. Disillusioned with her career, she became a spy for the Brazilian Espionage Network, where she excelled in her role. While

an assignment to retrieve a pyroplasmic gun, the weapon exploded in her hands, giving her the ability to generate green flames. Having failed in her mission, Beatriz became a fugitive. She found safety by joining the Global Guardians.

 **FLEUR-DE-LIS** Hailing from France, Noelle Avril was originally one of the Global Guardian members who didn't possess superpowers. Instead, this superior Olympic-level athlete was an expert in various weapons and forms of unarmed combat including martial arts, savate, and judo. Cybernetic enhancements upped her power level.

 **GODIVA** With her hair-controlling powers, Dorcas Leigh made her first appearance fighting alongside Elongated Man to stop a bomb in London. She was the first Super Hero to battle Toyman before he set up shop in Metropolis as one of Superman's foes.

 **ICEMAIDEN** Sigrid Nansen, who now identifies as nonbinary after being reintroduced during *Infinite Frontier*, was first introduced as the child of a Norwegian biochemistry specialist working with a group of scientists trying to duplicate the powers of Norway's legendary ice-people. Sigrid's mother pressured them to volunteer to be a test subject; as a result they gained the ability to produce large amounts of ice and snow and survive in severe cold temperatures, and this also gave their skin a blue hue. Through working with the Norwegian government, they developed the identity Icemaiden and trained for fieldwork, which led to them joining the Global Guardians as their country's representative. These days they go by Glacier.

# ICE

**FIRST APPEARANCE:** *JUSTICE LEAGUE INTERNATIONAL #12 (APRIL 1988)*

TORA OLAFSDOTTER REPLACED ICEMAIDEN ON THE GLOBAL GUARDIANS TEAM. THE NORWEGIAN WITH CRYOKINETIC ABILITIES INTRODUCED HERSELF AS A PRINCESS OF AN ISOLATED TRIBE OF MAGIC-WIELDING NORSEPEOPLE. SHE MADE UP THAT STORY BECAUSE SHE WAS ASHAMED OF HER UPBRINGING, WITH A FATHER WHO FORCED HER TO USE HER ABILITIES TO AID HIS CRIMINAL ACTIVITIES.

***IMPALA*** M'bulaze was born to the Zulu tribe in South Africa. He discovered at a young age that he could outrun and outjump antelopes. He possessed totemic powers similar to the hero Vixen's.

***JACK O'LANTERN*** In Ireland, Daniel Cormac encountered the fairy people known as the Sidhe. In exchange for his friendship, he was granted a magical lantern by the fairy queen Maeve. Armed with a mystical lantern that gave him powers of flight, flame projection, teleportation, illusion casting, enhanced strength, and the ability to generate fog, Daniel took up the identity Jack O'Lantern, becoming Ireland's Super Hero.

***LITTLE MERMAID*** Ulla Paske was the daughter of a mermaid from Tritonis and a legged denizen of Poseidonis. She was a mutant who could change her legs to a fish tail and fly above the water, but she could only survive underwater for thirty hours at a time.

 **OLYMPIAN** Aristides Demetrios was a rebellious man from Leivada, Greece. He had been jailed several times for petty crimes. One day, he stole the legendary Golden Fleece from a crate in the warehouse where he worked. The fleece possessed Aristides, giving him the personality and powers of Jason and his fifty Argonauts. As the Olympian, he was endowed with Hercules's strength, Atalanta's speed, Lynceus's vision, Admetus's intellect, Calais's flight, Peleus's telepathic immunity, and more.

 **OWLWOMAN** Wenonah Littlebird was an Indigenous woman endowed by her tribe's spirit with flight, night vision, and tremendous strength. When she decided to use her powers to represent her people to combat minor tribal crimes as well as Super-Villains, she landed on Dr. Mist's radar.

 **RISING SUN** Izumi Yasunari's grandparents were survivors of the US atomic bombing of Nagasaki in 1945. Like many, they eventually developed cancer and died. Izumi's mother also developed cancer but was healed through chemotherapy. The tragedy his family endured drove both Izumi and his brother to become doctors specializing in cancer research.

Izumi possessed the ability to absorb solar radiation, which led to him becoming Rising Sun. He was like a human solar battery and could create solar winds, heat, and light. He manipulated magnetic fields in order to fly.

 **SERAPH** Chaim Lavon was an Israeli schoolteacher whose divine powers were delivered from various Torah-based artifacts including the Staff of Moses, the Ring of Solomon, and the Mantle of Elijah, along with his long hair, which gave him the strength of Samson. However, if he committed a sin or abused any of his powers, they would go away until the next Yom Kippur.

 **TASMANIAN DEVIL** Hugh Dawkins was born with an uncommon ability to transform into a therianthropic Tasmanian Devil. His family had a hard time accepting him, but it wasn't just because of his outward appearance: Hugh was gay, but due to the Comics Code Authority, the character couldn't be open about it until now. Sadly, it wasn't until he saved his father's life that he earned his family's approval—something he should have had from the day he was born.

 **THUNDERLORD** Liang Xih-K'ai was a Buddhist monk and skilled martial artist who possessed a metagene that gave him a powerful sonic attack.

 **TUATARA** Jeremy Wakefield was born with a mutation that gave him a third eye. When he got older, he discovered he had precognitive abilities that allowed him to see the future. Adopting the name Tuatara after his country's native reptile, Jeremy became New Zealand's Super Hero representative for the Global Guardians.

 **TUNDRA** The Russian Tundra (real name unknown) could project ice and cold with super-strength. She joined at a time when the Global Guardians were in need of members, but little else is known about her.

 **WILD HUNTSMAN** Albrecht von Mannheim was a reincarnation of a German warrior and one of the few heroes based heavily in Germanic/Scandinavian mythos. Adopting the name of Wild Huntsman, he had superhuman strength, his dense muscle tissue allowing him to withstand great blows. A fan of animal companionship, he also had a black steed named Orkan and a dog named Donnerschlag.

# HELIX

**FIRST APPEARANCE:** *INFINITY INC.* #17 (AUGUST 1985)

**W**HAT HAPPENS WHEN A DERANGED SCIENTIST PREYS on impoverished communities? You get the Helix team. Dr. Benjamin "Amos" Love injected eight pregnant women with drugs to alter their children in the womb. When the babies were delivered, the doctor told their parents they were stillborn, so he could take the children unchallenged. He got only six of the eight babies because two of the women were deported before giving birth.

Dr. Love kept the children sheltered and deprived of moral sense. By isolating them, Dr. Love created an environment in which he was rarely challenged up until they became teens. Once they found out what Dr. Love had done to them over the years, they killed him and formed the Super-Villain group known as Helix.

**ARAK WIND-WALKER** Dr. Love's mutagenic drugs gave Arak his ability to control wind currents. He was a descendent of the legendary hero and shaman Arak Red-Hand. Like his "siblings" in Helix, Arak had little to no moral compass. He kept a low profile after Infinity, Inc. took him and his teammates into custody and they became wards of the state.

**BABY BOOM** Dr. Love's experimentation gave Baby the paranormal ability to cause explosions with her mind, a form of telekinesis. It also arrested her emotional and physical development to that of a five-year-old child.

Baby Boom adopted her childlike look at the insistence of Dr. Love, and she dropped it after taking over leadership of the Helix team when Mr. Bones was captured by Carcharo. She shortened her name to "Babe" and went with more of a punk-rock look. Babe wanted to be taken more seriously, something she struggled with, looking like a little girl. Her volatility made her more dangerous than the other Helix members.

 **KRITTER** Despite his feral appearance, Kritter was a scientific genius. He would mostly communicate through miming, grunts, and exaggerated expressions. He eventually developed a device—designed like a dog collar, naturally—to convert his barks into human speech.

 **MISTER BONES** Now known as Director Bones, the ex-leader of Helix had a bit of a journey to going straight and running the Department of Extranormal Operations. Because of Dr. Love's experiments, he was born with enhanced strength and stamina, and invisible flesh that produced cyanide. He grew up to be the leader of Helix.

After Mister Bones was mutilated by Carcharo and taken into custody, he began to reform, building a friendly rapport with Doctor Midnight (Beth Chapel), who helped him recover.

He was soon turned over to the custody of Infinity, Inc., where he had his first taste of superheroics. But after the team disbanded, Mister Bones took a local government job and started to work his way up the ladder.

**PENNY DREADFUL** gained the powers of absorbing and rechanneling electricity in vitro. Next to Mister Bones, Penny Dreadful was the second-oldest Helix member and acted as such. She would often bully the younger Helix members into compliance. Their shared experiences as elder siblings created a special bond between her and Mister Bones.

After Penny and her Helix teammates were separated, she popped up working as a secretary for Mister Bones when he took over the DEO. However, she didn't stay in this role very long and returned to a life of villainy, working with the sorceress Circe.

**TAO JONES** was proficient in martial arts, and she could manipulate attacks using force fields. She could also levitate.

Tao and her teammates agreed to check in to a low-security psychiatric hospital for the therapy and socialization they needed after all the trauma Dr. Love had inflicted on them. Tao would not be seen again until she worked with the Suicide Squad. It was on one of the many ill-fated Suicide Squad missions that Tao met her end.

**WILDCAT II & CARCHARO** Cousins Yolanda Montez and Carcharo (real name unknown) were not raised by Dr. Love, but they were born metahumans to mothers who were deported after receiving treatment from the mad doctor. The mutagenic drugs gave Yolanda sharp, retractable claws on her fingers and toes and cat-like reflexes and agility. Yolanda's mutations were easy to conceal, which allowed her to live a normal life. Carcharo, on the other hand, was born with the features of a human shark. His mother was frightened by his appearance. She tried to drown both herself and her son, but Carcharo survived. Before some of Yolanda's history was altered by the events of *Crisis on Infinite Earths*, she grew up to become a journalist. She worked for *Rock Stars Magazine* in Los Angeles, California, and soon after began her career as the new Wildcat, replacing the original when Ted Grant was injured and joining the Super Hero group Infinity, Inc. It was during her time with the team that she encountered her cousin Carcharo and Helix.

The orphaned Carcharo grew up underwater, without any kind of human supervision. Still, he managed to learn how to speak when he finally encountered his cousin Yolanda. Carcharo tried to take over control of Helix from Mister Bones but made the fatal mistake of biting off his leg, poisoning himself with the cyanide sweat Bones's skin produced.

# INFERIOR FIVE

FIRST APPEARANCE: SHOWCASE #62 (MAY/JUNE 1966)

**I**F YOU WANT A TEAM BURSTING AT THE SEAMS WITH CAMPY charm, look no further than the Inferior Five. They were the progeny of the Freedom Brigade, a successful Super Hero group from Earth-12. Each member had one problem or another that kept them from being the kind of heroes their parents were, but that's why nepotism exists.

After twenty years of peace in Megalopolis thanks to their parents' heroics, the Inferior Five was called to duty when mad scientist Dr. Gruesome settled in town with plans for global domination. The team of misfits somehow managed to work together effectively to defeat his newest creation, a robot designed to steal a jewel needed to complete his most dangerous weapon yet, a death ray. Their victory was mostly luck: Dr. Gruesome still obtained the jewels he needed and completed the work on his death ray, but it backfired on him. A win is a win. The success put them in good standing with the public, but they were still looked down upon by other heroes.

 **AWKWARDMAN** Leander Brent was the son of retired Freedom Brigade members Mister Might and Mermaid. He inherited both his parents' powers, super-strength and the ability to live underwater. He got the name Awkwardman because he was incredibly clumsy. He often tripped on his own feet or stumbled into his own teammates during battle, and his poorly tailored suit only made it worse. Awkwardman was more effective when Dumb Bunny swung him around by his cape, something she did quite often.

 **BLIMP** Herman Cramer was the son of Captain Swift. He could fly just like his father, as long as there was a strong wind to move him along, hence the alias Blimp. He did more damage to his teammates than to his foes. He was often thrown at them like a bowling ball, knocking them all down for a strike each time.

 **DUMB BUNNY** Athena Tremor was the daughter of Princess Power, a member of a lost subterranean Amazon tribe. Like her mother she had super-strength, so she served as the muscle for the Inferior Five. She was a model on the side, and teammate White Feather was usually the one photographing her. In her latest incarnation, she became known as Tough Bunny.

 **MERRYMAN** Leader of the team, Myron Victor, had smarts but little muscle. He aspired to be a cartoonist but answered the call of heroism when Dr. Gruesome struck.

 **WHITE FEATHER** William King was the son of Freedom Fighter hero the Bowman. He was a photographer by day and a subpar Super Hero by night. Although he was a skilled archer just like his dad, he suffered from intense anxiety around people who left him unable to hit his mark if anyone was watching.

# JUSTICE LEAGUE ANTARCTICA

FIRST APPEARANCE: JUSTICE LEAGUE INTERNATIONAL #23 (JANUARY 1989)

**O**F ALL THE PLACES FOR A JUSTICE LEAGUE FIELD OFFICE, Antarctica would definitely not be the first to come to mind. However, that did not stop the team's benefactor, Maxwell Lord, from placing a bunch of reformed Super-Villains who annoyed him to no end where the penguins reign supreme.

The group came together after Major Disaster's Injustice League disbanded. He and Big Sir ran into their former teammates at a New York City unemployment office and took the reunion as a sign to bring the group back together to steal a diamond. This did not go as planned at all. They encountered another team of villains attempting to steal the same diamond, but when police rolled in, it appeared as though Injustice League had saved the day by stopping the robbery.

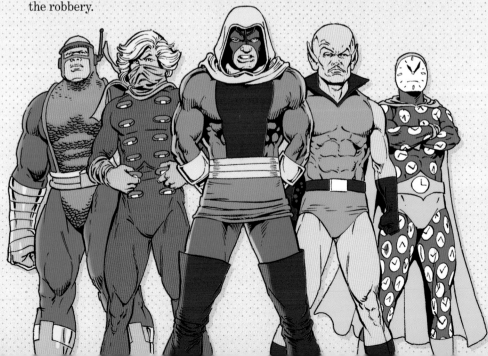

Perception was everything, and it worked in the former Injustice League's favor. The newspapers called them heroes. Major Disaster saw this praise as an opportunity to reach out to Maxwell Lord instead of going back to the unemployment office. To keep them together—as well as out of sight and mind—Lord sent them to staff the Antarctica branch of the Justice League. But that's not all; he also put G'nort in charge to keep the bothersome Green Lantern out of his hair.

G'nort was the only one who took his job seriously. And he was the only reason the team survived an assault by genetically altered killer penguins. The penguins reduced the headquarters to rubble, but G'nort used his power ring to wrap the team in a protective force bubble, keeping them safe until the main branches of the Justice League could dig them out.

 *BIG SIR* The hulking Dufus P. Ratchet was born with a malfunctioning pituitary gland, which caused him to grow to extreme proportions while leaving his mind developmentally stunted. The Rogues—The Flash's band of enemies—attempted to use his size to their advantage, equipping him with a high-tech suit of armor that also made him susceptible to suggestion. The ensuing rampage nearly killed The Flash. Big Sir was blindly loyal to a fault, willingly following the likes of Major Disaster. He also happened to be quite proficient at card games, breaking the bank at the Justice League Casino started by Booster Gold and Blue Beetle.

 *CLOCK KING* William Tockman spent most of his life taking care of his disabled sister. One day he found out that he had only six months to live. Since he was his sister's only caretaker, he did what any loving brother would do—he tried to rob a bank but tripped the alarm and wound up in jail.

While William was locked up, his sister passed, and—to make matters even worse—he found out his terminal diagnosis wasn't even correct. Instead, it was a colossal error by his doctor, who mixed up William's paperwork with another patient's. William swore revenge instead of suing for malpractice. Though he possessed no special powers, William had a devious and brilliant mind, able to predict with great accuracy in how many seconds imminent events should happen, which he used as he continued a life of crime. William also used a sword forged into the shape of a clock's hand that doubled as a walking stick.

 **CLUEMASTER** Before joining the Injustice League, Arthur Brown was a Gotham City villain and father of Stephanie Brown (who went on to become the Super Hero Spoiler). He was obsessed with figuring out Batman's identity, and to get the Dark Knight's attention, he would leave elaborate clues behind after his crimes. Naturally, this drew The Riddler's ire, who wanted to hold a monopoly on riddle-based crime in Gotham City, so he set Cluemaster up to take a fall.

 **MAJOR DISASTER** Paul Booker grew up to be a small-time crook with great teeth, thanks to his dad, an orthodontist. One day in his life of petty crimes, he stumbled upon an unlocked apartment window that just so happened to be the home of Thomas Kalmaku, a friend of Hal Jordan. It was here he discovered Thomas's Green Lantern casebook hidden behind a secret panel. Paul read just enough to obtain secrets behind both Green Lantern and The Flash.

He then hired a group of criminal scientists to design devices that could create disasters. Paul thought he would use them to expose the two heroes, but they blew up and scattered his atoms. After a month, his atoms coalesced and he was back to normal. Not one to be easily discouraged, Paul went back to the same scientists, and they put together a device that would prevent him

from being harmed by the disasters he caused. Over time, exposure to his weapons gave him the power of probability of chaos alteration—in other words, he could command chaos at will, from asteroid showers to heart attacks. Major Disaster continued to bounce back and forth between stints of villainy and heroics, which in and of itself was a form of chaos.

**THE MIGHTY BRUCE** Bruce was a small-time crook and assistant to Major Disaster. They met in jail, and when Major Disaster planned an escape, he made sure to bring Bruce with him. He even invited him to join the Injustice League. Bruce was a whiz with machines but couldn't keep himself out of jail.

**SCARLET SKIER** Dren Keeg was G'nort's archnemesis, but that clearly didn't stop G'nort from bringing him on to join the Justice League Antarctica. Once an aspiring performer—he specialized in dramatic introspective soliloquies—Keeg went on to work as a scout for the Interplanetary Designer Mister Nebula, who gave him the couture Cosmic Armor and skis he used.

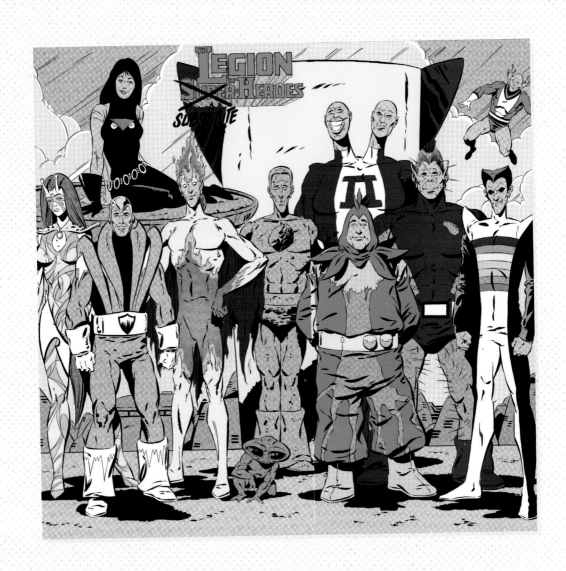

STRANGE AND UNSUNG ALL-STARS OF THE DC MULTIVERSE

# THE LEGION OF SUBSTITUTE HEROES

**FIRST APPEARANCE: ADVENTURE COMICS #306 (MARCH 1963)**

**I**F YOU CAN'T BE A MEMBER OF THE LEGION OF SUPER-HEROES, then where else could you go? The Legion of Substitute Heroes, of course! The team was comprised of Legion rejects who wanted to keep their heroic dreams alive. The concept for the team came from Polar Boy, who thought there should be a place for these heroes, even if the Legion didn't recognize their value.

Polar Boy found others a bit less sanguine that any degree of dedication could overcome the inadequacies of their powers. But his enthusiasm was infectious, and he convinced the other rejects to give their best and take pride in contributing whatever they could.

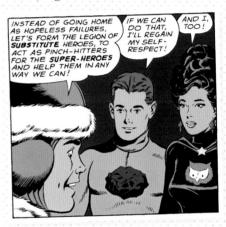

INSTEAD OF GOING HOME AS HOPELESS FAILURES, LET'S FORM THE LEGION OF *SUBSTITUTE* HEROES, TO ACT AS PINCH-HITTERS FOR THE *SUPER-HEROES* AND HELP THEM IN ANY WAY WE CAN!

IF WE CAN DO THAT, I'LL REGAIN MY SELF-RESPECT!

AND I, TOO!

The team was originally planned to secretly fill in for and assist the Legion of Super-Heroes, but as the Legion's problems grew increasingly complex, the Substitutes started to get sidelined. Of course, this caused their feelings of inadequacy to resurface, and the team eventually disbanded.

**ANTENNAE BOY** Khfeurb Chee Bez is the superpowered manifestation of eavesdropping. He was born on the planet Grxyor, and his uniquely shaped ears allowed him to tune into any kind of broadcast at any time.

When it was time for his audition for the Legion of Super-Heroes, he gave Cosmic Boy an ear full of hurt—a drawback of his listening abilities was a deafening feedback loop. He was immediately rejected as a result.

The silver lining was that his rejection brought his abilities to the attention of the Metropolis Time Institute, and they swiftly reached out to him. He helped researchers collect ancient recordings to add to their expanding historical knowledge.

Eventually Antennae Boy became an auxiliary member of the Legion of Substitute Heroes. They also found his powers to lack practical use, but they didn't want to reject him outright. After a few appearances with them, Khfeurb went on to become a news broadcaster—arguably the best fit for someone with his powerset.

 **CHLOROPHYLL KID** Ral Benem hailed from the planet Mardru and traveled all the way to Earth to try out for the Legion. He had the ability to super-accelerate the germination and growth of any plant life, which he accidentally acquired falling into a tank of hydroponic serum as a child. Though it was a power that Poison Ivy probably would have appreciated, the Legion didn't think it would be useful on missions.

 **COLOR KID** Ulu Vakk of the planet Lupra gained his special ability to change the color of objects through his clumsiness, a trait that never bodes well for a lab assistant. While stumbling his way through an experiment, Ulu accidentally irradiated himself with multidimensional light rays. He walked away with his life and the limited ability to affect the electromagnetic properties of any object, altering its wavelength and thus changing its color.

Color Kid's abilities were aesthetically pleasing but had no practical use: at least that is what members of the Legion of Super-Heroes thought when he auditioned. He also gave a sloppy presentation. Color Kid freaked Superboy out by making him green, which sealed the deal for his immediate rejection. The Legion was kind enough to send him packing with directions to the Legion of Substitute Heroes. While working with them, he soon discovered his powers could be effective as a psychological weapon.

It was a good thing he leveled up while with the Substitutes too. When the Legion came looking for him to help change a green Kryptonite cloud hovering over Earth, Color Kid was up to the task. He changed the cloud's color, which allowed Superboy to come back to Earth. Color Kid walked away from the situation with a pep in his step and a new outlook on the growing potential of his powers. For instance, he went on to earn a living by generating quality lighting for musical entertainers. Not so bad for a clumsy lab assistant.

 **DOUBLE HEADER** Dyvud and Frenk Retzun were from the planet Janus, whose inhabitants descended from a group of genetically engineered humanoids that were part of a eugenics program to create superpowered beings. These test subjects were rescued by Legionnaire Mon-El, who brought them to their new home.

All Janusians are born as one individual, but over the course of their natural lifespan they split into two beings with identical chromosomes. Where Dyvud and Frenk differed from other Janusians was in having different and often incompatible personalities.

The pair known as Double Header constantly argued with one another, and this was one of two reasons they were rejected by the Legion of Super-Heroes. The other was that their powers, or lack thereof, were virtually useless, according to Saturn Girl. The Legion of Substitute Heroes couldn't find use for their powers either, but like Antennae Boy, they didn't want to outright reject Double Header, so they made them auxiliary members.

 **DREAM GIRL** was a native of the planet Naltor. All Naltorians possessed precognitive abilities, but they didn't all possess the kind of heroic drive that made Nura Nal stand out. From a young age she was destined to be one of the most accurate prophets in the history of Naltor and a thriving scientist. The exact opposite could be said of her sister Mysa, who eventually left Naltor.

When Nura tried to find her sister using her abilities, she instead had a premonition of the deaths of all the members of the Legion of Super-Heroes, which made her seek out the team. Even though Nura knew that she would forfeit her chance to succeed her mother as High Seer, she still left Naltor. She soon learned that her vision wasn't exactly correct. What she saw were actually android copies of the Legionnaires, and there was no connection to her missing sister.

Both discoveries made Nura take a temporary leave from the Legion, which was how she became a member of the Legion of Substitute Heroes. She spent her time with them perfecting her powers and fostering a budding relationship with Star Boy. Both she and Star Boy eventually regained their memberships with the Legion of Super-Heroes. Unlike Star Boy, Nura proved herself to be a most valuable Legionnaire. When Dream Girl was elected leader of the Legion, she was forced to defend the United Planets against Darkseid in her very first mission.

 **FIRE LAD** Staq Malvern came from the planet Shawr to apply for a membership with the Legion. He thought he had a chance because he could breathe fire, a power he gained after inhaling the fumes of a weird meteor. The Legion saw him as more of a hazard than a help and rejected him.

 **INFECTIOUS LASS** Drura Sehpt was a native of Somahtur. Like other Somahturians, her body was in a symbiotic relationship with thriving colonies of diseases, both viral and bacterial. She couldn't live without the diseases, and they couldn't live without her. Because of all the infectious diseases thriving on Somahtur, the planet was kept secret and under tight quarantine to all except the personnel of Medicus One—a satellite hospital—who were sometimes sent to collect or store samples of diseases deemed too dangerous to be kept at an ordinary medical site.

Drura was one of their experimental subjects. She escaped Medicus One to try out for the Legion of Super-Heroes with her ability to transmit any disease of her choosing to others. They rejected her because her powers were too dangerous. Like Porcupine Pete, with whom she formed a friendship, she didn't spend much time perfecting her abilities. As a result, Drura accidently infected bystanders frequently, which was one of many reasons Polar Boy disbanded the team after he gained entry to the Legion.

 **NIGHT GIRL** Lydda Jath was a native of the planet Kathoon. She wanted nothing more than to become a member of the Legion, so her father formulated a serum that changed her DNA, effectively giving her superpowers. There was a catch, though—because of the way the planet's inhabitants adapted to the perpetual darkness, she could use her powers only at night or in deep shadow. Unfortunately, this catch led to her rejection by the Legion.

 **POLAR BOY** Brek Bannin was from Tharr, one of the hottest planets in the galaxy. Natives adapted by developing the power to create cold, snow, and ice to combat the heat. Although Brek used his powers every day of his life, he was unable to control them when he tried out for Legion membership and was rejected accordingly. His dogged determination not only birthed the Legion of Substitute Heroes but eventually earned him a position on the main team.

 **PORCUPINE PETE** Despite his outward appearance Peter Dursin was far from a prickly character with a rough upbringing. Peter was born with very tough skin. His parents found it uncomfortable to hold him; however, they showed Pete love and affection in other ways. As a result, he grew up with a well-developed, outgoing, friendly personality that attracted many friends.

Over time, the rough spots on Pete's body developed into individual spikes that then grew into quills, which he discovered would fire in all directions if he got angry or scared. With much practice, he could project the quills from his body at will. At the suggestion of his friends, Pete tried out for the Legion of Super-Heroes, but the audition did not go as planned. Although he had the ability to propel the quills from his body with force, the members of the Legion of Super-Heroes learned he also had no control over the direction the quills went. Pete was immediately rejected.

Porcupine Pete eventually found himself a spot on the Legion of Substitute Heroes roster, but he still didn't manage to refine control of his power. Pete's time with the Substitutes was just as chaotic as his abilities and remained that way until the group disbanded.

 **RAINBOW GIRL** Hailing from the planet Xolnar, Dori Aandraison was awarded a trip to Earth for winning the Miss Xolnar contest. She won thanks to her powers—Dori had a heightened pheromonic field that made her personality irresistible to everyone within the vicinity of the rainbow light she emitted. She hoped to become a member of the Legion of Super-Heroes as a stepping stone to her ultimate career goal to be a holovid actress.

After Dori was rejected by the Legion, she married a member of one of the wealthiest families in Metropolis so she could stay on Earth. This also gave her time to rethink her strategy. She considered joining the Legion of Substitute Heroes as an alternative, although she thought they didn't get enough publicity to do her any good as an aspiring actress. Years later, she joined the Substitutes' ranks, helping overthrow the xenophobic Justice League of Earth.

 **STAR BOY** Thom Kallor hailed from the planet Xanthu. He was born in a stellar observation station run by his parents. His unique birthplace gave him the ability to draw mass from the stars and transfer it at will to make any object extremely heavy. After his manifesting powers destroyed the observation station, he returned planet-side to be studied by doctors, enduring many painful tests as a result. To escape being tortured in the name of science, Thom ran away from home. In his haste to leave Xanthu, Thom's cruiser passed through the tail of a comet whose radiation gave him additional superpowers akin to Superboy's.

Thom gained membership in the Legion of Super-Heroes. While on the team, he fell in love with teammate Dream Girl. That love led to his downfall. Thom killed her ex Kenz Nuhor in self-defense and was expelled from the Legion after fellow Legionnaire Brainiac 5 determined Thom could have stopped Kenz without using lethal force.

But his relationship with Dream Girl would also bring him to the Legion of Substitute Heroes. When she joined the group, Thom followed to be close to her.

 **STONE BOY** Dag Wentim came from the planet Zwen, where colonizers developed the ability to transform into a dormant stone state to hibernate through the six-month-long sunless periods. Unlike most Zwennites, Dag didn't want to spend half his life in a dormant state and was driven to visit other planets.

When Dag reached Earth, he learned about the Legion of Super-Heroes but was rejected because all he could do was be an unconscious stone. When the Legion of Substitute Heroes went on missions, Stone Boy would turn into an inanimate statue, and his teammates would drop him on a villain from above or use him as a battering ram. Thanks to some hypnotherapy, he eventually learned to remain conscious when (literally) petrified.

# NEW WAVE AND WINDFALL

FIRST APPEARANCE: BATMAN AND THE OUTSIDERS #8
(MARCH 1984, NEW WAVE), #9 (APRIL 1984, WINDFALL)

**B**ECKY JONES WAS A RUTHLESS METAHUMAN with the power to turn any part of her body to water—solid, liquid, or gas. She could also control large bodies of water to create tsunami-like tidal waves. Once Becky discovered her powers, she used them to kill her parents and to torture her younger sister, Wendy. Both sisters gained their powers from the prenatal experiments to which their mother willingly subjected herself.

As New Wave, Becky formed and became the leader of a group of elemental Super-Villains called the Masters of Disaster. With the combined use of her powers and intimidation, New Wave ruled the team with an iron fist. She was severely vengeful, and most feared the consequences of disobeying her orders. She drowned her teammate Shakedown when he refused to kill a hostage. Meanwhile, Wendy Jones lived her life in fear of the trauma Becky inflicted on her.

When Wendy grew older, Becky pressured her to join the Masters of Disaster. Wendy could control the wind, so even though she didn't actually want to be part of the team, she was a good fit as Windfall. Wendy was reluctant to carry out orders, one time saving the hero Halo despite her sister's demands to kill her.

Wendy soon stood up to Becky, who promised to kill her one day. Though Wendy joined the Super Hero group the Outsiders for a time, she was lured into joining the rogue Strike Force Kobra, pitting her against her former Outsiders teammates.

Even after Wendy dropped the Windfall act again, she fell victim to the evils of the world. While in college, she was drugged and assaulted by members of a fraternity. To add insult to injury, pictures of the incident were spread across campus. Yet because she was a former Super-Villain, she was the one expelled from school. In response, she returned to the school and killed the fraternity members. For her crimes, Wendy wound up with the Suicide Squad, where she met her end. She died a hero, protecting others from radioactive Chemo when his mind was hijacked and her windshield was overcome by his blast.

Becky never got her revenge and wound up imprisoned in a large test tube by the Justice Society of America.

# THE NUCLEAR FAMILY

FIRST APPEARANCE: *THE OUTSIDERS* #1 (NOVEMBER 1985)

**D**R. SHANNER TOOK INADEQUATE SAFEGUARDS AGAINST radiation and inadvertently exposed both himself and his beloved family to its effects. As his family started to die around him, Dr. Shanner vowed to teach the world what he deemed to be the truth about nuclear weapons, even if it took a major destructive event to do it.

The misguided scientist was clearly unhinged by this trauma, but instead of seeking therapy or some kind of grief counseling, he put his efforts into constructing five robots that resembled his younger self and his family, designed to function like a stereotypical 1950s family.

To show the world the result of true nuclear destruction, Shanner sent the robots out to destroy the city of Los Angeles, California. The Outsiders destroyed the robots before the doctor's plan could come to fruition.

# SCARE TACTICS

FIRST APPEARANCE: SHOWCASE '96 #11 (DECEMBER 1996)

**T**HE SCARE TACTICS WERE A ROCK BAND MADE UP OF TEENAGE monsters who escaped government custody. The mysterious R-Complex held each of them captive as part of a secret government program until they were freed by conspiracy theorist Arnold Burnsteel.

Arnold was the perfect person to free the teenagers. He was a living, breathing encyclopedia of arcane trivia, conspiracy theories, and questionable "facts." Arnold was Jared Stevens's go-to when he took over the Doctor Fate mantle. Fate helped Arnold break into R-Complex.

At first, the group went its separate way after Arnold helped Fang, Grossout, Screem Queen, and Slither escape and dropped them off in New York City. After an impromptu rock performance as the newly named Scare Tactics, the group decided to set up a covert mobile headquarters and hit the road with Arnold. Though on the run from government agents, they were determined to hide in plain sight as the band.

**FANG** Lead guitar player Jake Ketchum was a member of a werewolf clan from the Appalachian Mountains. Their only neighbors were a rival clan, the Knightsbridges. To stop the family feud, the two clans arranged for Jake and one of the Knightsbridge girls, Pearl, to marry. Jake wasn't at all interested and ran away from home. He was picked up by the R-Complex, who took him to the facility in New Mexico where he met his future band mates. After he left the band, he went on to star in the TV series *Wendy the Werewolf Stalker*.

**GROSSOUT** When drummer Philbert Hoskins was young, he loved gazing up at the stars. Through his telescope, he witnessed a meteorite crash and went to investigate. Upon his arrival, a bright light from the meteorite turned him into a walking pile of sludge. He was the only member the R-Complex didn't have to kidnap—his mother called up the feds to take him away because she couldn't afford to feed him. As the drummer, Grossout was the backbone of Scare Tactics, and he did his best to be a reassuring presence to his team, even if they didn't always understand him because of the way his sludge form affected his speech.

**SLITHER** Bass player James "Jimmy" Hilton spent his childhood being experimented on by his biochemist father, who was obsessed with inducing immunity to cancer. As a result of the cruel experiments, Jimmy mutated into a reptile. It affected more than just his appearance; Jimmy felt his reptile side taking over his mind. After a stint in the circus, Slither wound up imprisoned by R-Complex. He harbored an unrequited love for Scream Queen.

**SCREAM QUEEN** After surviving a mass slaying of her family in her home country of Markovia, vampire and lead singer Nina Skorzeny fled to the United States, where she was captured and placed in Operation: Prodigy. She didn't trust humans—rightfully so given her history with them. She wasn't a big fan of Burnsteel but begrudgingly agreed with most of the decisions he made for the group.

Scream Queen possessed all the vampiric traits, including immortality, the power to hypnotize, superhuman agility and strength, and the ability to turn into a small black cat. She also had a sonic scream she used in battles and on stage. Her influences included Siouxsie and the Banshees and Andy Warhol.

# JET

FIRST APPEARANCE: *MILLENNIUM #2 (JANUARY 1988)*

BELIEVING HUMANITY READY TO TAKE ITS PLACE IN THE GREATER UNIVERSE, GUARDIAN OF THE UNIVERSE HERUPA HANDO HU AND ZAMARON NADIA SAFIR CHANNELED THEIR POWERS INTO THE MILLENNIUM PROJECT TO ENDOW TEN CHOSEN INDIVIDUALS WITH IMMORTALITY AND METAHUMAN POWERS. THEY BECAME THE NEW GUARDIANS.

**H**ERUPA AND NADIA VISITED CELIA WINDWARD, a young Jamaican woman living in Great Britain, and told her she had been chosen. She turned them down at first because she wanted nothing to do with saving a world that was doomed anyway. Celia, like many around the globe, felt disillusioned by Super Heroes after a massive smear campaign started by G. Gordon Godfrey—an orator with powers of persuasion sent to Earth by Darkseid. His campaign resulted in outlawing Super Hero activities until hubris got the best of him. It took the president giving a televised speech to help ease public concern almost a year later. The speech also resulted in Celia effectively changing her mind about becoming a Super Hero herself. She gained the ability to control electromagnetism, which allowed her to fly and project energy.

    Off to the club for a girls' night out with New Guardians teammate Gloss, Celia encountered Hemo-Goblin. Together, she and Gloss scared him off, but not before he bit her. Celia's other two teammates, Harbinger and Extraño, were also bitten the following day when the team went looking for him. The rest of Celia's New Guardian teammates tracked Hemo-Goblin down and defeated him. It was not until later they learned he died of AIDS.

    Contracting HIV was by far the most difficult battle of Jet's life as a New Guardian. It fortunately brought her closer to both Harbinger and Extraño, and the three formed a support system for each other, unlike anything seen in comics before or since.

Jet was the only one of the three to see her HIV progress into AIDS. She went to Kilowog, a Green Lantern and friend of the New Guardians, with hopes of repairing her immune system, but the attempt failed. Even as Celia continued as a Super Hero, she was shown taking a host of prescriptions for AIDS. Her teammates did all they could to make sure she took

her meds and got the rest she needed, even as Celia remained determined to be an active member of the team. She continued to battle on two fronts—both for her life and against evil with the New Guardians. Celia single-handedly stopped an alien invasion using her powers, but the herculean effort was too much for her. She showed a great deal of strength and humility in that moment, and her teammates promised to continue to honor her spirit by giving their all as New Guardians.

Years later, Jet resurfaced, alive and leading the Global Guardians. Her disposition was a 180-degree change. She and the rest of her team were under the thrall of two Faceless Hunters in a plot to capture Hal Jordan. Under their control, Jet renounced the actions of the Green Lantern, claiming they violated national sovereignty and undermined the Global Guardians. She'd return once more, this time falling victim to Prometheus as he hunted down and killed members of the Global Guardians.

JET

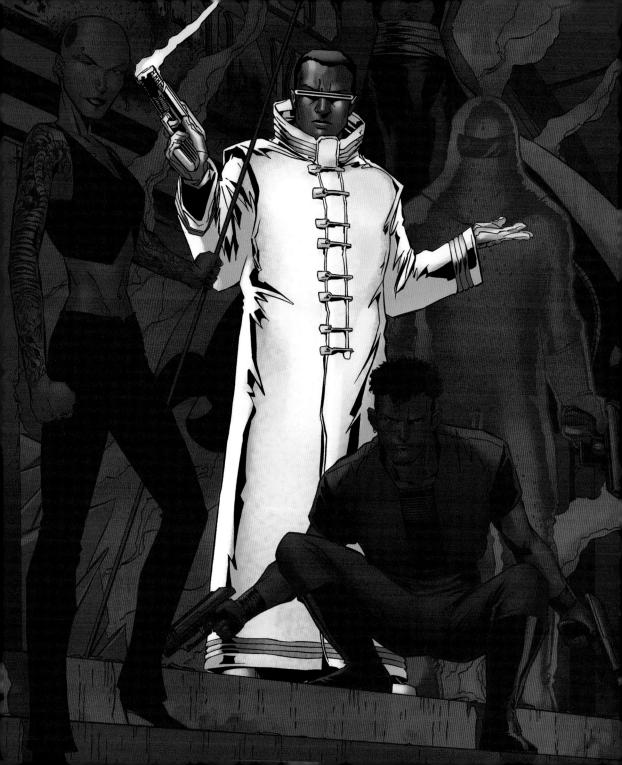

# DEJA VIEW

**G**IVEN ALL THE WORLDS AND VARIOUS DIMENSIONS, DOPPELGÄNGERS ARE A DIME A DOZEN IN THE DC MULTIVERSE. MORE THAN JUST DUPLICATES FROM PARALLEL EARTHS, THE CHARACTERS IN THIS SECTION MAY SHARE A POWER OR CODENAME WITH A FAR MORE ESTABLISHED CHARACTER BUT ARE NO CARBON COPIES. THESE WHOLLY UNIQUE CHARACTERS ARE UNFORGETTABLE IN THEIR OWN RIGHT.

# CHILL

FIRST APPEARANCE: GOTHAM UNDERGROUND #3 (FEBRUARY 2008)

CHILL WAS A MEMBER OF A GROUP OF VILLAINS THE PENGUIN put together for his protection. The sole purpose of Chill's existence was to replace Captain Cold, but he was no carbon copy. Unlike Cold, Chill's heart was a little more defrosted, although he did threaten to kill Cold's father. It didn't matter, however, because Cold wanted to kill his father himself. This led to what could be considered a mirror fight between the two masters of cold, but Captain Cold came out the victor, killing Chill with an ice blast to the face.

*STRANGE AND UNSUNG ALL-STARS OF THE DC MULTIVERSE*

# HARLEQUIN IV

FIRST APPEARANCE: *GREEN LANTERN CORPS QUARTERLY* #5 (JUNE 1993)

**N**O, NOT *THE* HARLEY QUINN. NOR THE ORIGINAL HARLEQUIN, who married the Golden Age Green Lantern (Alan Scott). And not Marcie Cooper, the granddaughter of the original Manhunter (Dan Richards) and foe of Infinity, Inc. And are we counting Duela Dent? Regardless, THIS Harlequin debuted by attacking Alan Scott. She used her abilities to induce hallucinations that made Alan believe he was fighting his former foes Solomon Grundy and the Icicle. She later attacked Alan's wife, which made him lose his temper. For some reason this triggered a vision of him as the lord of Hell and her as his slave. It was enough to freak Harlequin out. She declared that Alan "ruined everything" and fled the scene, appearing only briefly once more as one of the villains the devil Neron summoned to wage war on Earth's heroes.

Her brief spotlight left questions. Why was she obsessed with Alan Scott? Why did she think illusion casting was a good way to flirt with a married man? How would she feel knowing that Alan is now out of the closet?

ALAN!

HE'S BEEN YOURS LONG ENOUGH!

WITHERED OLD CRONE.

*DEJA VIEW*

# JONNI THUNDER

FIRST APPEARANCE: *JONNI THUNDER* #1 (FEBRUARY 1985)

**A** TOUGH AND DEDICATED PRIVATE EYE, JONNI THUNDER learned everything from her father and mentor, Jim Thunder. Shortly after her father died, Jonni came into possession of a Peruvian statue that released an energy being called Mzzttexxal. Unbeknownst to Jonni, this malevolent, parasitic alien needed to possess humanoid host bodies to survive. Mzzttexxal had come to Earth eons ago, but because she could find no suitable host, she hibernated in the statue. Once Jonni inadvertently awakened her, she found a suitable host.

Jonni initially thought she wielded control of Mzzttexxal, which she called Thunderbolt, much like Golden Age Super Hero Johnny Thunder did with his genie-like companion. But in Jonni's case, that wasn't completely true. Jonni had to be unconscious whenever Mzzttexxal was active. And through the use of Jonni, Mzzttexxal plotted to release the other members of her race and take over the world. With the aid of her boyfriend Skyman (Sylvester Pemberton) and his Infinity, Inc. teammates, Jonni thwarted Mzzttexxal's plan, at the price of losing her newfound energy-based powers. But that didn't deter her from continuing her PI career and chasing down criminals when the need arose.

# MISS AMERICA

FIRST APPEARANCE: *MILITARY COMICS #1 (AUGUST 1941)*

**I**F YOU HAD A VENN DIAGRAM OF LOIS LANE and Wonder Woman, Joan Dale would be right in the center. The gutsy reporter—who actually predated Wonder Woman—was transformed into the Super Hero Miss America by the good folks over at Project M. Joan was only trying to do her due diligence as a reporter when a man disguised as an informant drugged her. Spoiler alert, he wasn't an informant. He was a US government official named Agent X, hired by none other than Professor Mazursky. While under the influence of these drugs, she experienced strong hallucinations. She imagined a conversation with the Statue of Liberty in which she was told the power to alter matter would be bestowed upon her. When Joan awoke from her drugged state, she boarded a ferry to head back to Manhattan, where her powers manifested for the first time as she came to the rescue of an elderly man. He called her the real Miss America, and Joan ran with it.

She quit her job as a reporter and was hired as a secretary at the FBI, but once a reporter, always a reporter. She went snooping to follow a lead on a man named Ramon, a musician in cahoots with his government to hit a US military base with a surprise drone attack. Ramon and his men discovered Dale, locked her in a chest, and attempted to dump her in the river. Dale used her powers to escape and save the military base.

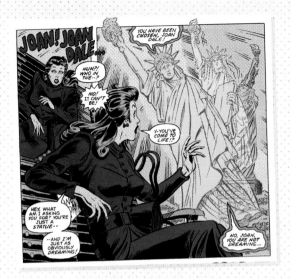

Joan was never just a Super Hero. She wore multiple hats, but the compensation certainly didn't reflect it. She joined the Justice Society of America, the Super Hero team that fought during World War II as part of the All-Star Squadron. She served as the team's  secretary but also acted as a nurse after the team saved a navy officer named Derek Trevor (no relation to Steve Trevor). Joan fell in love with Trevor while he recovered under her care. Around this time, she also began losing her powers, and she took a leave of absence from the Justice Society. Joan traded in her cape for a wedding ring, marrying Derek and soon after adopting a daughter, Hippolyta, who went on to join the team Infinity, Inc. as the Super Hero Fury.

A time later, Joan revealed she never truly lost her powers. Instead, she used them to create an illusion so that she could retire and enjoy a normal life with her husband. It was only after he passed away that she allowed the illusion to fade away. Years later, she came out of retirement and used her powers to restore her youth.

# TANA MOON

FIRST APPEARANCE: ADVENTURES OF SUPERMAN #501 (JUNE 1993)

**T**ANA MOON WAS INTRODUCED AS A LOIS Lane–type character for the clone Superboy following the historic *Death of Superman* story line, but she was much more than that surface-level analysis reveals. When Tana made her debut, she was frustrated about *Daily Planet* editor in chief Perry White not taking her seriously as a reporter because she was still in school. As she stormed out, sulking about the bake-off assignment White offered her, she caught Superboy's attention.

At this time in Superboy's history, he truly leaned into the boy of it all, lacking major amounts of maturity. As a result, he left a less-than-stellar impression on Tana. He told her that she was way too hot to be a reporter, a comment that only angered her more, especially right on the heels of Perry White dismissing her credentials. Superboy managed to save face and a future relationship with Tana by agreeing to give her an exclusive interview on the WGBS network, which led to Tana securing a news anchor job and becoming Superboy's personal reporter.

The young reporter may have been hungry for the opportunity to grow her career, but Tana still had lines she didn't want to cross. Once it became clear that her boss and WGBS president, Vinnie Edge, only cared about the ratings Superboy brought in, she took a stand. It was a pivotal moment for her both as a character and as a genuine friend to Superboy.

Tana eventually left her job with WGBS, but she wasn't unemployed for long. She secured a position as a television reporter when she moved back home to Hawaii. Superboy followed to be close to his friend, and the two managed to maintain a friendly and professional relationship. That friendship

did eventually turn romantic, which was slightly problematic because Tana was approximately twenty-two, and Superboy was artificially aged to sixteen.

Tana lost much of her momentum—and agency—after that. Her character was reduced to an insecure love interest. After Tana broke up with Superboy, she left Hawaii for another job. But instead of rising to prominence, her life was cut short after Tana became the obsession of Amanda Spence, an operative for a shadowy group known as the Agenda, who had designs on Superman.

# DR. CLAIRE FOSTER

FIRST APPEARANCE: SUPERMAN #176 (JANUARY 2002)

PSYCHIATRIST DR. CLAIRE FOSTER HAD A ONE-OF-A-KIND INTRODUCTION, MEETING SUPERMAN AT ONE OF THE HERO'S MOST VULNERABLE MOMENTS.

**A**LWAYS LOOKING OUT FOR HIS FRIENDS, MARTIN MANHUNTER recommended Claire to Superman after the Man of Steel realized his mental health wasn't invulnerable like his physical body.

Superman opened up to Dr. Foster and revealed his most guarded secret—years earlier, he had executed General Zod and the other two Kryptonians from a parallel universe who had committed planetary genocide with their bare hands. Superman admitted he didn't want to kill them, but he believed it was the only option at the time. The grief these actions caused him contrasted with his feelings about a recent encounter with Manchester Black, whom Superman wanted to kill but didn't. Processing these experiences with

Claire allowed Superman to heal and become a better version of himself.

We next saw Claire with Teen Titans member Starfire, whose sessions were a lot more intense. It's important to note the significance of a character like Starfire seeking therapy, even if reluctantly and at the request of Donna Troy. Starfire hailed from Tamaran, a planet whose culture was pro-joy, but Starfire herself was a warrior and had been enslaved by her own sister in the past—experiences her upbringing didn't prepare her to process. Although Starfire had been the most joyful Teen Titans member, it became

clear during her sessions with Claire that she didn't know joy outside of the team. Claire did a great job of leading Starfire to own the idea that she hadn't truly ever asked herself what she wanted and instead found false contentment fighting for everyone but herself. Through Claire, we were afforded a raw look at what made Starfire the hero we knew. Exploring other aspects of her character than her bubbly personality also made her more relatable.

Dr. Claire Foster made just one more appearance, in which she was reimagined as a daytime TV healthcare "professional," more interested in ratings than helping Super Heroes.

# MUHAMMAD X

FIRST APPEARANCE: *SUPERMAN* #179 (APRIL 2002)

DURING THE SAME ERA AS DR. FOSTER, MUHAMMAD X HAD A BLINK-AND-YOU-MISS-IT MOMENT IN COMICS, WITH AN ALIAS INSPIRED BY TWO MEN HE BELIEVED REALLY SERVED THE BLACK COMMUNITY—MUHAMMAD ALI AND MALCOLM X. HE WAS THE PROTECTOR OF HARLEM, NEW YORK, USING HIS ABILITY TO ALTER DENSITY AND GRAVITY. ALTHOUGH SUPERMAN DIDN'T KNOW MUHAMMAD X WHEN HE RAN INTO THE HERO, NATASHA IRONS DID, AND SHE PROCLAIMED MUHAMMAD X ONE OF HER FAVORITE HEROES, NEXT TO HER UNCLE STEEL.

*DR. CLAIRE FOSTER*

# TECHNO-RABBLE

**T**ECHNOLOGY IS THE WAY OF THE FUTURE, AND SOME OF THESE CHARACTERS WERE WAY AHEAD OF THEIR TIME. EVEN THOUGH MANY WERE OVERLOOKED OR MISUNDERSTOOD, THAT DOESN'T TAKE AWAY FROM THEIR INNOVATIVE QUALITIES.

# THE BLUE SNOWMAN

FIRST APPEARANCE: SENSATION COMICS #59 (NOVEMBER 1946)

**B**LUE SNOWMAN WAS A GOLDEN AGE WONDER WOMAN VILLAIN whose alias suggested a man behind the mask . . . perhaps a very disgruntled Frosty the Snowman. But Blue Snowman was actually a woman named Byrna Brilyant. She took a page right out of Ma Hunkel's book of letting her costume speak for herself but, in this case, for nefarious reasons.

Byrna was a schoolteacher in the small town of Fair Weather Valley. Her late father, a scientist, invented a form of precipitation that instantly froze whatever it touched. She decided to use the invention for profit but thought she had to take on an outwardly masculine identity to be taken seriously. Thus the Blue Snowman came to be.

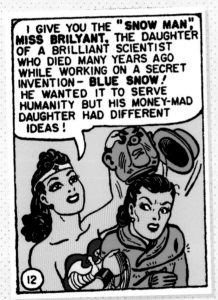

Byrna used her telescopic snow ray on farmers, demanding their life savings to unfreeze their crops and livestock. After Wonder Woman caught her, Byrna was imprisoned on Transformation Island, a subsidiary island to Themyscira, used by the Amazons to rehabilitate female Super-Villains Wonder Woman captured. She was later freed by Eviless, a slaver from the Empire of Saturn. As payment for her freedom, Byrna joined Villainy, Inc.

In her post-*Crisis* appearance, she was a former member of the Ice Pack, a group of ice-themed Super-Villains. Ironically, she was kicked out for not being cool enough, even though she had a variety of weaponry, including a hat that made blue snow and a smoking pipe that projected icicles.

# DJINN

FIRST APPEARANCE: SUICIDE SQUAD #1 (MAY 1987)

**T**HE DIGITAL MAN KNOWN AS DJINN was an enemy to both the Outsiders and the Suicide Squad, serving as a member of the Jihad, a team of superpowered international terrorists-for-hire operating out of the outlaw nation of Qurac. He was once a living man but was reduced to 1s and 0s by Jihad scientist Jess Bright. When he wasn't locked away like some computerized genie, Djinn could pass through walls, destroy machines, and kill with his digitized hands. To keep him occupied, he was hooked up to a computer at night to simulate an artificial life.

# HACK

FIRST APPEARANCE: SUICIDE SQUAD #2 (NOVEMBER 2016)

**B**ORN IN KENYA, ZALIKA (LAST NAME unknown) was an extremely intelligent metahuman who could teleport herself and others through the internet and download files directly to her brain. To go along with her supergenius, Hack was also a huge fan of Harley Quinn. In fact, she had Harley's iconic diamonds tattooed on her face. She became a fan of Harley when she first saw her on the cover of *Fight* magazine. She was enamored with Harley's colorful, bright, glamorous attitude, which represented the type of freedom Hack longed to experience herself.

When Zalika was younger, she was forced to work for a local gang in the Korogoro slums, but she escaped by trapping her captors inside a mobile phone and killing them with a computer virus.

Her hacking travels ultimately led to joining Task Force X, though things weren't any easier for her there. Captain Boomerang killed Zanika, but because of the nature of her metahuman powers, Hack wasn't truly dead. Her leftover code in Belle Reve's cloud systems allowed her to reform a sense of herself.

Hack eventually downloaded herself into the cybernetic body of the Wall, a government supersoldier, which she used to hold all of Washington, DC, hostage, including the president. It was all for show, though. Hack's true plans were to get information on Amanda Waller by accessing the Pentagon computer systems. However, no one gets the best of Waller. Hack was defeated and presumed dead after her cybernetic body lost battery power.

*TECHNORABBLE*

# L-RON

FIRST APPEARANCE: JUSTICE LEAGUE INTERNATIONAL #14 (JUNE 1988)

**L**-RON WAS A ROBOT CONSTRUCTED by melodramatic intergalactic salesman Lord Manga Khan. In addition to being programmed to use unfair trading advantages to con others out of their valuables, L-Ron was a bit of a pacifist. Running away to live another day was a philosophy he adopted early on rather than ever sticking around to fight.

In his first appearance, L-Ron was traded to the Justice League. L-Ron enjoyed assisting the team, mainly working with Martian Manhunter and Max. When the rogue conqueror Despero attacked, L-Ron sacrificed his body to construct a control collar for the villain. The plan didn't work exactly, and instead L-Ron's consciousness was imprinted into Despero's body for a time. Eventually he was restored to his shiny robotic glory.

# LETONYA CHARLES

FIRST APPEARANCE: WONDER WOMAN #179 (MAY 2002)

**L**ETONYA CHARLES WAS A YOUNG AND FASHIONABLE woman who loved to hit the clubs. She also had serious addictions, which led to her use of the superdrug Tar. The drug granted its user superhuman strength and musculature for a period. The aftereffects of Tar were quite harsh, and the drug destroyed LeTonya's body.

LeTonya was given a second chance at life thanks to her aunt Sarah Charles, the same scientist who helped repair the Super Hero Cyborg. LeTonya became Cyborgirl, but the entire ordeal made her antisocial, in stark contrast to her former personality. It was later revealed that her reconstruction was part of a secret S.T.A.R. Labs project called Project M. Her aunt and uncle were covertly the star engineers of the initiative.

As Cyborgirl, Charles joined Villainy, Inc., a group made up of several Wonder Woman villains. The leader, Queen Clea, recruited Cyborgirl exclusively for her ability to interface with ancient Atlantean computers. On her first mission, Cyborgirl got lost in cyberspace, and her teammate Trinity had to take over her mind along with the computer systems. Ironically enough, it was Wonder Woman who freed her.

Mr. Orr of Project M, a black ops government organization, eventually recruited Cyborgirl. He wanted her to join the Cyborg Revenge Squad, which functioned as a safeguard to prevent Cyborg from exposing Project M.

*TECHNORABBLE*

# SKEETS

FIRST APPEARANCE: BOOSTER GOLD #1 (FEBRUARY 1986)

**S**KEETS WAS A FORMER BX9 SECURITY ROBOT that worked at the twenty-fifth-century Space Museum, where he first met Booster Gold. The fame-hungry hero used this cute orb of genius to become wealthy and to stop disasters before they happened.

Don't let the adorable robot appearance fool you, though. Skeets was as opinionated as they come, and he didn't hold back. He constantly corrected Booster during his battles with criminals. Skeets's feedback wasn't all scathing, however. Once in a while, he would give Booster some encouragement.

After Booster Gold became a member of Max Lord's Justice League, Skeets was placed in storage. He didn't see any action again until he was reactivated after Doomsday destroyed Booster's power suit. Skeets was unable to repair the suit, but he made Booster Gold a new one using the alien technology Blue Beetle had—the Exorian Flesh Driver.

For all of Skeets's hard work, he was downloaded into the suit. As the Flesh Driver, Skeets could advise Booster, and he could take control of his body and motor functions whenever Booster was knocked unconscious. Skeets finally got a robotic body of his own after Professor Hamilton built Booster Gold a new suit using technology like his original.

Skeets got his defining character moment in the *52* story arc. When he failed to properly predict the future because of what Booster thought was a malfunction, the discovery kicked off a chain of events that eventually revealed that the villain Mister Mind wanted to consume the newly reborn multiverse. Skeets trapped Mister Mind and defeated him.

I'M SORRY, BUDDY-- LIFE'S BEEN PRETTY HECTIC. I'LL MAKE IT UP TO YOU.

IT'S OKAY. I MOSTLY MONITORED CABLE AND SURFED THE INTERNET.

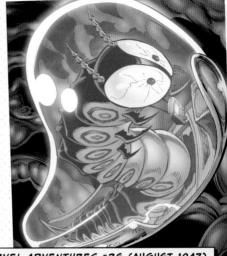

# MISTER MIND

FIRST APPEARANCE: *CAPTAIN MARVEL ADVENTURES* #26 (AUGUST 1943)

A SENTIENT CREEPY-CRAWLY FROM THE PLANET VENUS, MISTER MIND WAS NOTHING LIKE THE WORMS FROM PLANET EARTH. HE HAD POWERS OF TELEPATHY AND TELEKINESIS, AS WELL AS THE DISGUSTING ABILITY TO SPAWN HIS OWN BROOD FROM THE ORAL CAVITY OF A HOST BODY.

MISTER MIND FIRST TRAVELED TO EARTH TO MEET THE STAR OF A POPULAR RADIO PROGRAM—A VENTRILOQUIST DUMMY. MUCH TO MISTER MIND'S DISAPPOINTMENT, THE DUMMY DIDN'T HAVE MUCH TO SAY. AS FATE WOULD HAVE IT, MISTER MIND DISCOVERED A NEW PASSION—GLOBAL CONQUEST, WHICH HE SOUGHT BOTH ON HIS OWN AND ALONGSIDE THE MEGALOMANIACAL DOCTOR SIVANA. WHAT NEITHER MASTER MIND NOR DOCTOR SIVANA ACCOUNTED FOR IN THEIR SCHEME WAS SHAZAM!, WHO OFTEN THWARTED BOTH OF THEM.

TECHNORABBLE

# SY BORGMAN

FIRST APPEARANCE: *HARLEY QUINN #2 (MARCH 2014)*

**A**FTER STOPPING A TERRORIST GROUP RUN BY THE RUSSIAN Tolstakk brothers, former US government employee Sy Borgman nearly missed out on cashing in his 401(k). Sy was left with permanent damage to most of his body. The government replaced his body parts with then state-of-the-art bionics, effectively turning him into a Swiss army knife. As he grew older, however, he likened his enhancements to "carrying around 400 pounds of pastrami."

Sy crossed paths with Harley's psychiatrist alter ego at the nursing home where he lived. Sy came to her for her killing expertise instead of her psychiatric care; he needed help completing one last mission for his country. And in turn Sy helped Harley find out who had put the bounty on her head. The team-up blossomed into a beautiful friendship.

The retiree enjoyed being looped into Harley's zaniness, and he fit right in. From frequenting nude beaches to having surprise birthday parties thrown for him, Sy was living it up in his twilight years. Who needs grandkids when you have Harley Quinn and her friends?

*STRANGE AND UNSUNG ALL-STARS OF THE DC MULTIVERSE*

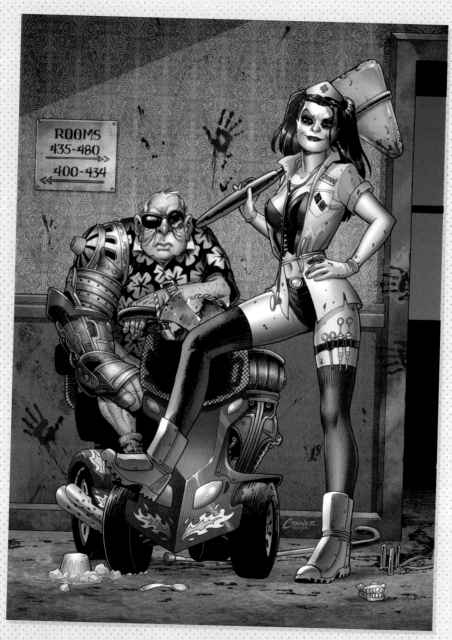

TECHNORABBLE

215

# CHESHIRE

FIRST APPEARANCE: *NEW TEEN TITANS ANNUAL #2 (SEPTEMBER 1983)*

BEFORE BECOMING THE DEADLY ASSASSIN KNOWN AS CHESHIRE, JADE NGUYEN HAD A DIFFICULT ROAD AHEAD OF HER FROM A YOUNG AGE. HER MOTHER HAD AN AFFAIR WITH SENATOR ROBERT PULLMAN WHILE HE WAS A SOLDIER IN VIETNAM, AND SHE RAISED THEIR DAUGHTER ALONE.

JADE WAS LATER KIDNAPPED BY slavers but eventually killed her master. Afterward, she fully dedicated herself to making sure no man would ever rule over her like that again. Jade gained some of the skills she used as Cheshire from a freedom fighter named Wen Ch'ang, who unofficially adopted her. She learned the rest from a man she married at sixteen. Kruen Musenda, an African assassin who went by Spitting Cobra, taught Jade everything he knew for two years before she ultimately surpassed him . . . and then fatally poisoned him. Adopting the alias Cheshire, she began her career as an assassin and had frequent run-ins with the Teen Titans.

But it wasn't a fight with a Titan that left an impact on her life. Speedy (Roy Harper) was hired by the government to get all the intel he could on Cheshire and turn her in. Things did not go as planned for Roy or the government because he fell in love with her. Unbeknownst to him, however, Jade was pregnant with their daughter, Lian. Life as a mercenary did not bode well for motherhood. No matter how much Jade loved her daughter, she could not commit to raising her, so she left Lian with Roy.

Despite her solo hustle, Cheshire went on to work with the Tartarus, Secret Six, and the Injustice League Unlimited. During her time with the Secret Six, she conceived her second child, Thomas Blake Jr., with Catman. But her affiliations put the child in danger, as young Thomas was kidnapped. Catman discovered when he tracked down their son that the kidnapping was revenge against Cheshire for some of her ill deeds. Catman placed the child with a loving couple and decided to let Jade believe their son was dead rather than bring him back into their world of danger.

Although Cheshire may not have been proficient in motherhood, she was proficient in assassination and was one of the greatest Teen Titans foes. Her agility and speed allowed her to dodge Starfire's blasts and defeat Jesse Quick. She was an expert in both poison and serving couture looks. She used her artificial poisoned fingernails to make her opponents tremble, attacking both their nervous system and their confidence in their style. She was regarded the world's second-deadliest assassin, justifying her choice of career over family.

# OUT OF THIS WORLD

**H**EROES, VILLAINS, AND THOSE WHO FALL SOMEWHERE IN BETWEEN COME FROM EVERYWHERE IMAGINABLE IN THE DC MULTI-VERSE. THE CHARACTERS IN THIS SECTION HAILED FROM THE WORLDS FARTHER THAN THE NAKED EYE CAN SEE INTO THE VASTNESS OF SPACE. SOME LEFT THEIR HOME PLANETS OR DIMENSIONS IN HOPES OF JOINING SUPER HERO TEAMS, WHILE OTHERS MERELY WANTED TO EXPLORE ALL THE MULTIVERSE HAD TO OFFER THEM. WHATEVER THEIR REASONS FOR LEAVING HOME, THEIR STORIES PROVE SUPERMAN WASN'T THE ONLY INTERESTING ALIEN OUT THERE.

# COMET QUEEN

## FIRST APPEARANCE: *LEGION OF SUPER-HEROES* #304 (OCTOBER 1983)

**G**RAAVA ALWAYS HAD HER OUT-OF-THIS-WORLD appearance thanks to her Quaalian heritage, but she acquired the powers she used as Comet Queen after she jumped into the tail of a comet . . . naked. She was hoping to replicate the original powers of Star Boy so she could join the Legion of Super-Heroes. Her plans didn't go the way she assumed.

When she came out the other side of the comet's tail, she had much different powers. Her mutation gave her the ability to fly at super-speed while trailing a stream of stellar energy—just like a comet. Her hair also allowed her to hide in the cloud it formed or put people to sleep with its fumes.

Bouncing Boy invited Graava to join the Legion Academy after she saved him from a volcanic vent they were both stuck in. The entire time she annoyed him to no end. Her overly bubbly demeanor and eccentric way of talking aggravated those around her more often than they lifted anyone's spirits. Though she would never actually become a member of the Legion of Super-Heroes, she did eventually join a short-lived version of the Legion of Substitute Heroes.

*STRANGE AND UNSUNG ALL-STARS OF THE DC MULTIVERSE*

# DEMONIA

FIRST APPEARANCE: GREEN LANTERN #141 (JUNE 1981)

**D**UARMZSHEE-PAAN STARTED OUT WORKING IN MAMA Madame's bordello in the city of Rashashoon with her sister, Harpis. There, she developed a network of connections she thought would give her some clout in the Citadel, the tyrannical and oppressive empire ruling the Vega star system. She was wrong, however; her sister proved to be the more popular one.

While still working in the bordello, she and her sister were enslaved by Tamaranean Citadel commander Blackfire (sister of Teen Titans member Starfire). She had them both genetically modified to suit the tastes of her soldiers. While Harpis did not care for her new reptilian look, Demonia embraced hers and used it to gain what she always wanted—power.

If it weren't for her sister, Demonia would probably not have joined the elite unit of revolutionaries called the Omega Men, who sought to overthrow the Citadel. When Harpis became a member, Demonia followed along. Although she was a member, her true desires did not shift to align with her teammates. Instead, Demonia covertly curried the favor of the Citadel by betraying the Omega Men.

OUT OF THIS WORLD

# HYATHIS

**FIRST APPEARANCE: JUSTICE LEAGUE OF AMERICA #3 (MARCH 1961)**

**H**YATHIS'S SWEET AND DOCILE APPEARANCE COULDN'T have been further from the truth for the queen of Alstair. She and the rest of the planet's inhabitants were plant/humanoid hybrids. Hyathis uniquely possessed empathic control over all plant life on Alstair but had no empathy for the leaders of the three planets with which she was continuously at war in the Antares solar system.

Rival ruler Kanjar Ro, from the insect planet Dhor, lured the Justice League of America into this conflict when he used his Gamma Gong to hypnotize the Super Heroes and force them to fight Hyathis and the other warring planets' leaders.

In the waters of Alstair, Hyathis battled against both Wonder Woman and Aquaman, and nearly claimed victory. She was ultimately subdued by Wonder Woman's Golden Lasso. The Justice League ended the war for good by exiling all four leaders to a barren planet.

Hyathis's loyal followers came to her rescue and brought her to the planet Thanagar. The planet was in the throes of the Equalizer Plague, which robbed Thanagarians of their individuality. But that cure came with a major condition: Hyathis demanded to be crowned the only monarch of Thanagar. She got her wish, as the lingering effects of the plague made the Thanagarians submissive. It took Hawkman returning to his home world with the help of Superman and Batman to free his people of her hold.

BUT...

YOU CAN *NEVER* BE OUR QUEEN!

THEN, AS *RULER* OF THANAGAR, I *BANISH* BOTH OF YOU FROM THIS WORLD--*FOREVER!*

# FIRE JADE

FIRST APPEARANCE: AMETHYST, PRINCESS OF GEMWORLD #4 (AUGUST 1983)

**L**ADY EMERALD WAS A NOBLE OF THE GEMWORLD, a magical dimension once belonging to the Lords of Chaos. As the ruler of the House of Emerald and mother of three daughters, she led a far from normal life. When Lady Emerald was young, she suffered the trauma of being sucked into a limbo-like dimension, which left lasting emotional damage. Her mental state continued to crumble after her eldest daughter was given as tribute to the master of the Gemworld, Dark Opal.

Driven mad by the loss of her daughter, Lady Emerald soon found herself removed from power and poisoned by her own vizier, Arliyan. But death did not come as expected with the poison. In the limbo realm years earlier, a demonic entity had placed an enchantment on her that prevented her spirit from fully passing on. The demonic entity returned, promising Lady Emerald a way back to the world of the living, at the cost of draining Gemworld of its magic, effectively destroying the world.

Lady Emerald took the demon up on the offer, and Fire Jade began her attack. Had it not been for Amethyst, the hero of Gemworld and Lady Emerald's middle daughter, she might have gone through with the plot. Instead, she chose to accept her death and give up her life so that magic and the realm would survive.

*OUT OF THIS WORLD*

# STARFINGER

FIRST APPEARANCE: ADVENTURE COMICS #335 (AUGUST 1965)

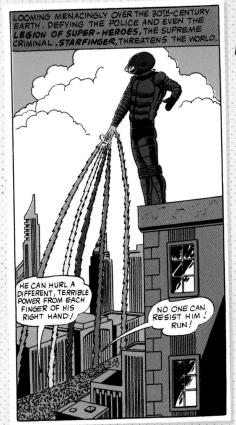

LOOMING MENACINGLY OVER THE 30TH-CENTURY EARTH, DEFYING THE POLICE AND EVEN THE *LEGION OF SUPER-HEROES*, THE SUPREME CRIMINAL, *STARFINGER*, THREATENS THE WORLD.

HE CAN HURL A DIFFERENT, TERRIBLE POWER FROM EACH FINGER OF HIS RIGHT HAND!

NO ONE CAN RESIST HIM! RUN!

**L**ARS HANSCOM WAS A NOTED PHYSICIAN and the first Starfinger, an enemy of the Legion of Super-Heroes. He was Lightning Lad's doctor, allegedly working on a new organic limb to replace Lightning Lad's prosthesis. Unfortunately, he was up to no good, attempting to brainwash the hero into becoming the villain Starfinger in a plot to extort the leaders of Earth of the world's entire supply of Rejuvium—a fountain-of-youth wonder drug. Lars was desperate to get his youth back because he was troubled by the very idea of aging.

The Legionnaires foiled his plans, and the only thing Lars gained was the idea to become Starfinger himself. And that was a choice. He went on to spoil Bouncing Boy and Duo Damsel's wedding, kidnapping both of her two bodies in a plot to duplicate her powers. Superboy thwarted Lars's scheme, dressing like the villain's double and pretending the experiment worked. This embarrassing defeat didn't stop Lars. He went under the knife, altering his appearance to impersonate Saturn Girl's obstetrician in an elaborate plot to get close enough to her husband Lightning Lad to brainwash him again. But Lightning Lad was ready for him this time, having been conditioned to resist the villain's hypnosis.

IMPUDENT. WILDFIRE, YOU MAY *BELIEVE* YOUR POWER IS GREAT, BUT IT HAS NOT YET BEEN *TESTED* AGAINST MINE!

NO MAN SPEAKS TO STARFINGER IN SUCH TONES!

THERE WERE NEARLY MORE STARFINGERS THAN YOU COULD COUNT ON ONE HAND. LARS WAS EVENTUALLY KILLED BY HIS SUCCESSOR, CHAR BURRANE. AFTER BURRANE, CRIME LORD MOLOCK HANSCOM TOOK OVER THE NAME. AND IN ANOTHER TIMELINE, THE LEGIONNAIRE ELEMENT LAD ASSUMED THE IDENTITY WHILE UNDER THE INFLUENCE OF MIND CONTROL FROM UNITED PLANETS PRESIDENT CHU.

YES, STARFINGERR HE'LL BE RROOTING FORR THE HOME TEAM TODAY.

AND AS YOU KNOW, STARFINGERR DOES NOT LIKE TO LOSE...

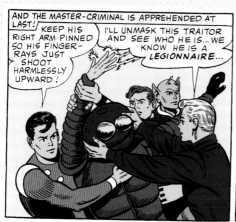

AND THE MASTER-CRIMINAL IS APPREHENDED AT LAST!

KEEP HIS RIGHT ARM PINNED SO HIS FINGER-RAYS JUST SHOOT HARMLESSLY UPWARD!

I'LL UNMASK THIS TRAITOR AND SEE WHO HE IS... WE KNOW HE IS A *LEGIONNAIRE*...

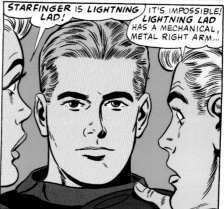

STARFINGER IS *LIGHTNING LAD!*

IT'S IMPOSSIBLE! *LIGHTNING LAD* HAS A MECHANICAL, METAL RIGHT ARM...

*OUT OF THIS WORLD*

# QUISLET

FIRST APPEARANCE: LEGION OF SUPER-HEROES #14 (SEPTEMBER 1985)

IT'S NO EASY FEAT TO GET INTO THE LEGION OF SUPER-HEROES (JUST ASK THE MEMBERS OF THE LEGION OF SUBSTITUTE HEROES). THE LEGION IS A TOUGH CROWD TO IMPRESS, BUT QUISLET, AN ENERGY BEING FROM THE DIMENSION OF TEALL, MANAGED TO SECURE AN INVITATION.

**A** MICRODIMENSION ACCESSIBLE ONLY THROUGH A BLACK HOLE, Teall is home to a genderless, subatomic race of group-minded beings composed of pure energy. Teallians can inhabit and animate almost any form of matter, though their energy quickly disintegrates the objects they possess.

Quislet's actual name is unpronounceable, and writers generally refer to him with the pronouns he/him. Independent thinking and a mischievous spirit set him apart from his fellow Teallians. His individuality got him selected to pilot the Trans-D-Vessel—an experimental craft that wouldn't disintegrate—and seek out other energy beings that could be absorbed into the Teallian hive

mind. But that same individuality prompted Quislet to blow off his mission and dive straight into a black hole in pursuit of adventure. Though he was a bit of a nuisance to local authorities in the thirtieth century, he soon found himself in the presence of the Legion of Super-Heroes, whom he wowed with his power levels and his support in apprehending a group of city bombers. Quislet thrived as a member of the Legion, even using his knowledge to help fellow energy-based Legionnaire Wildfire form a corporeal body for a time. Despite the best efforts of the Teallians to retrieve Quislet, he continued to make his way in the universe. At one point, the Emerald Empress destroyed the Trans-D-Vessel, requiring Quislet to leave the Legion and return home to Teall. But true to his plucky energy, he eventually made his way back in a newly constructed ship.

# WRITER AND ILLUSTRATOR CREDITS

THIS BOOK FEATURES STORIES AND ILLUSTRATIONS ACROSS THE YEARS OF DC HISTORY. RUNNING PRESS HAS MADE EVERY EFFORT TO IDENTIFY AND ACKNOWLEDGE THE WRITERS AND ARTISTS WHOSE WORK APPEARS IN THESE PAGES.

JACK ABEL
DANIEL ACUÑA
ARTHUR ADAMS
NEAL ADAMS
MARLO ALQUIZA
BILL ANDERSON
MURPHY ANDERSON
ALFRED ANDRIOLA
ROSS ANDRU
JIM APARO
MICHELE ASSARASAKORN
CHRIS BACHALO
MICHAEL BAIR
DAVID BALDEÓN
JIM BALENT
MATT BANNING
AL BARE
MIKE W. BARR
EDUARDO BARRETO
EDDY BARROWS
SAMI BASRI
CARY BATES
CHRIS BATISTA
ERIC BATTLE
JOHN BEATTY
SCOTT BEATTY
C.C. BECK
JOE BENNETT
OTTO BINDER
STEVE BIRD
TEX BLAISDELL

JON BOGDANOVE
BRETT BOOTH
GERALDO BORGES
WAYNE BORING
RON BOYD
PAT BOYETTE
KEN BRANCH
RUSS BRAUN
E. NELSON BRIDWELL
MARK BRIGHT
JUNE BRIGMAN
PAT BRODERICK
JOHN BROOME
AL BRYANT
BRIAN BUCCELLATO
RICH BUCKLER
DANNY BULANDI
KURT BUSIEK
JOHN BYRNE
JIM CALAFIORE
ROBERT CAMPANELLA
W.C. CARANI
NICK CARDY
FRED CARILLO
MAURO CASCIOLI
RICHARD CASE
JOEY CAVALIERI
JOHN CELARDO
KEITH CHAMPAGNE
ERNIE CHAN
ROSEMARY CHEETHAM

MINGJUE HELEN CHEN
FRANK CHIARAMONTE
IAN CHURCHILL
YILDIRAY CINAR
MATTHEW CLARK
BECKY CLOONAN
DAVE COCKRUM
GARY COHN
VINCE COLLETTA
ERNIE COLON
AMANDA CONNER
KEVIN CONRAD
GERRY CONWAY
PARIS CULLINS
TONY S. DANIEL
PETER DAVID
MIKE DECARLO
JOSE DELBO
JOHN DELL
J.M. DEMATTEIS
KIM DEMULDER
TOM DERENICK
NICK DERINGTON
TONY DEZUNIGA
WELLINGTON DIAZ
STEVE DILLON
PAUL DINI
CHUCK DIXON
DALE EAGLESHAM
STEVE ENGLEHART
GARTH ENNIS

MIKE ESPOSITO
RIC ESTRADA
MARK FARMER
WAYNE FAUCHER
EBER FERREIRA
JULIO FERREIRA
BILL FINGER
BRENDEN FLETCHER
SANDU FLOREA
JOHN FORTE
GARDNER FOX
RAMONA FRADON
GARY FRANK
GEORGE FREEMAN
KERRY GAMMILL
JOSÉ LUIS GARCÍA-LÓPEZ
CARLOS GARZÓN
DREW GERACI
FRANK GIACOIA
VINCE GIARRANO
DAVE GIBBONS
IAN GIBSON
JOE GIELLA
KEITH GIFFEN
JOE GILL
DICK GIORDANO
JONATHAN GLAPION
AL GORDON
SID GREENE
TOM GRUMMETT
GREG GULER
EDMOND HAMILTON
BOB HANEY
SCOTT HANNA
CHAD HARDIN
RON HARRIS
DOUG HAZLEWOOD
DON HECK
MIKE HERNANDEZ
DON HO
MIKE HOFFMAN

DAVE HOOVER
SANDRA HOPE
RICHARD HOWELL
JOYE HUMMEL
DAVE HUNT
ROB HUNTER
JAMAL IGLE
CARMINE INFANTINO
JACK JADSON
MIKEL JANÍN
PHIL JIMENEZ
GEOFF JOHNS
CHRIS JONES
J.G. JONES
MALCOLM JONES III
RUY JOSÉ
DAN JURGENS
LEN KAMINSKI
GIL KANE
ROBERT KANIGHER
RAFAEL KAYANAN
STAN KAYE
KARL KERSCHL
BARBARA KESEL
KARL KESEL
RICK KETCHAM
JACK KIRBY
TYLER KIRKHAM
GEORGE KLEIN
TODD KLEIN
SCOTT KOBLISH
SCOTT KOLINS
PETE KRAUSE
JOE KUBERT
PAUL KUPPERBERG
ANDY LANNING
GREG LAROCQUE
ERIK LARSEN
JIM LEE
STEVE LEIALOHA
PAUL LEVITZ

STEVE LIEBER
ROB LIEFELD
STEVE LIGHTLE
JOHN LIVESAY
JEPH LOEB
ALVARO LOPEZ
DAVID LOPEZ
JOHN LOWE
MIKE MACHLAN
KEVIN MAGUIRE
LARRY MAHLSTEDT
FRANCIS MANAPUL
TOM MANDRAKE
MIKE MANLEY
GUILLEM MARCH
PABLO MARCOS
LAURA MARTIN
MARCOS MARTIN
ROY ALLAN MARTINEZ
RON MARZ
JOSÉ MARZAN, JR.
SHELDON MAYER
JOHN MCCREA
LUKE MCDONNELL
TODD MCFARLANE
ED MCGUINNESS
MARK MCKENNA
MIKE MCKONE
FRANK MCLAUGHLIN
SHAWN MCMANUS
LINDA MEDLEY
GRANT MIEHM
AL MILGROM
DAN MISHKIN
LEE MODER
DOUG MOENCH
SHELDON MOLDOFF
STEVE MONTANO
JIM MOONEY
JEREOM MOORE
TOM MORGAN

WRITER AND ILLUSTRATOR CREDITS

| | | |
|---|---|---|
| GRANT MORRISON | NORM RAPMUND | JIM STARLIN |
| WIN MORTIMER | RICHARD PIERS RAYNER | ARNE STARR |
| PAUL MOUNTS | GABRIEL REARTE | JOE STATON |
| JEFFREY MOY | ROY RICHARDSON | LARY STUCKER |
| TODD NAUCK | FRANK ROBBINS | CURT SWAN |
| DON NEWTON | JERRY ROBINSON | PHILIP TAN |
| IRV NOVICK | RODIN RODRIGUEZ | JORDI TARRAGONA |
| JOHN NYBERG | DANNY RODRIQUEZ | TY TEMPLETON |
| DENNIS O'NEIL | BOB ROGERS | ROMEO TENGHAL |
| BOB OKSNER | PRENTIS ROLLINS | GREG THEAKSTON |
| ARIEL OLIVETTI | GEORGE ROUSSOS | ART THIBERT |
| PATRICK OLLIFFE | STÉPHANE ROUX | DANN THOMAS |
| JERRY ORDWAY | MIKE ROYER | ROY THOMAS |
| JOE ORLANDO | JOE RUBINSTEIN | FRANK TIERI |
| JOHN OSTRANDER | BERNARD SACHS | BRUCE TIMM |
| JIMMY PALMIOTTI | GASPAR SALADINO | JON TIMMS |
| DAN PANOSIAN | ALEX SAVIUK | HARVEY TOLIBAO |
| EDUARDO PANSICA | KURT SCHAFFENBERGER | ANTHONY TOLLIN |
| GEORGE PAPP | NICOLA SCOTT | ALEX TOTH |
| YANICK PAQUETTE | TREVOR SCOTT | SAL TRAPANI |
| CHARLES PARIS | STEPHEN SEGOVIA | CHAZ TRUOG |
| BILL PARKER | MIKE SEKOWSKY | ANGEL UNZUETA |
| ANDE PARKS | VAL SEMEIKS | PETER VALE |
| SEAN PARSONS | JIM SHERMAN | RICARDO VILLAMONTE |
| BRUCE PATTENSON | JIM SHOOTER | TREVOR VON EEDEN |
| CHUCK PATTON | JON SIBAL | WADE VON GRAWBADGER |
| PAUL PELLETIER | JERRY SIEGEL | MATT WAGNER |
| ANDREW PEPOY | JOE SIMON | BRAD WALKER |
| GEORGE PÉREZ | GAIL SIMONE | LEN WEIN |
| HARRY G. PETER | DAVE SIMONS | ED WEXLER |
| WILL PFEIFER | ROGER SLIFER | CHRISTIAN WILDGOOSE |
| KHOI PHAM | JOHN SMALLE | ANTHONY WILLIAMS |
| JOE PHILLIPS | ANDY SMITH | ROB WILLIAMS |
| SEAN PHILLIPS | BOB SMITH | SCOTT WILLIAMS |
| WARREN PLEECE | CAM SMITH | BILL WILLINGHAM |
| ALBERTO PONTICELLI | RAY SNYDER | KEZ WILSON |
| HOWARD PORTER | RICHARD SPACE | STAN WOCH |
| JACK PURCELL | JACK SPARLING | MARV WOLFMAN |
| BILL QUACKENBUSH | DAN SPIEGLE | BILL WRAY |
| MAC RABOY | DICK SPRANG | DOSELLE YOUNG |
| HUMBERTO RAMOS | CHRIS SPROUSE | |
| RON RANDALL | CLAUDE St. AUBIN | |

WRITER AND ILLUSTRATOR CREDITS

# ACKNOWLEDGMENTS

Thank you to past me for taking a leap of faith into a new chapter of life, even when it was terrifying.

A very special thank-you to my husband and son for cheering me on and knowing when to pull me away from my keyboard.

Thank you to my best friend, Aaron, for being available via text or call. You kept me from swan-diving into the abyss.

I am grateful to Brandon for thinking of me regarding this project. You have no idea how much I appreciate you.

All thanks to my editor, Randall Lotowycz, for your editorial guidance, support, and patience.

Thank you to every single creator who had a hand in bringing these characters into existence. This book wouldn't be a thing without them. I appreciate your imagination more than words can say.

# ABOUT THE AUTHOR

**AFTER GRADUATING FROM THE UNIVERSITY OF ILLINOIS AT CHICAGO** and entering a career in scientific research, Stephanie Williams pivoted to pursue her childhood dream of writing comic books when she became a mom. She now has two ongoing webcomics, *Parenthood Activate* and *But What If Though*, in addition to *Living Heroes* on Kickstarter. Her comics credits include *Marvel Voices: Legacy, Wonder Woman: Black and Gold, Nubia and the Amazons, Trial of the Amazons, Nubia: Coronation Special, Nubia: Queen of the Amazons, Wakanda*, and more. When she isn't reading or writing comics, Stephanie enjoys spending time with her husband and son.